The Civil War in Art

A VISUAL ODYSSEY

Doranne Jacobson

TODTRI

DEDICATION
This book is dedicated to members of my family who have stood with me upon the battlefields of the Civil War and walked with me where Lincoln walked: Dorothy Novy Wilson, Russell E. Wilson, Elsie B. Novy, Robert L. Novy, Jerome Jacobson, Laurie Jacobson, Joshua Jacobson, Patti Wilson, Jacqueline Wilson, Pamela Wilson Sartorelli, and Wendy Wilson.

ACKNOWLEDGMENTS
I wish to express appreciation for the use of the collections at Lincoln Library, Springfield, Illinois, Brookens Library at the University of Illinois at Springfield, the Illinois State Library, the New York Public Library, and the libraries of Columbia University, New York. I also wish to thank Jerome Jacobson, John Walthall, Pamela Sartorelli, Karl Lunde, and Roy Moyer for their editorial suggestions.

This book was designed and published by
TODTRI Book Publishers
254 West 31st Street
New York, NY 10001-2813
Fax: (212)695-6984
E-Mail: Info@todtri.com

Printed and bound in Singapore

ISBN 1-880908-84-0

Visit us on the web!
www.todtri.com

Author: Doranne Jacobson

Publisher: Robert M. Tod
Book Designer: Mark Weinberg
Production Coordinator: Heather Weigel
Senior Editor: Edward Douglas
Project Editor: Cynthia Sternau
Assistant Editor: Don Kennison
Picture Reseachers: Julie DeWitt, Laura Wyss
Desktop Associate: Paul Kachur
Typesetting: Command-O, NYC

Picture Credits

American Heritage Century Collection, New York 29, 42, 102, 118, 122

The Birmingham Museum of Art, Alabama 119

The Brooklyn Museum, New York 55

Art Brown Collection/Nawrocki Stock Photo 34, 43, 44, 48, 49, 123

The Chicago Historical Society 6, 39, 69, 111

Collections of the State Museum of Pennsylvania 108-109, 116-117, 120-121

Cooper-Hewitt, National Design Museum, Smithsonian Institution, Art Resource 14, 28, 62

Corbis-Bettmann 23

Detroit Institute of Arts, Michigan 70-71

Fenton Historical Society, Jamestown, New York 15

Fogg Art Musuem, Harvard University Cambridge, Massachusetts 88-89

Gettysburg National Military Park Museum, Pennsylvania 66-67, 110

Robert M. Hicklin, Jr. Inc., Spartanburg, South Carolina 20-21

Indianapolis Museum of Art, Indiana 5

Library of Congress, Washington, D.C. 30, 31, 32-33, 63, 72-73, 75, 81, 82, 83, 84, 85, 86, 87, 91, 92, 93, 94, 95

The Lincoln Museum, Fort Wayne, Indiana 108

Mercer Museum, Bucks County Historical Society, Pennsylvania 107

The Metropolitan Museum of Art, New York 10-11, 56-57, 60, 61

Museum of Fine Arts, Boston 8-9, 13, 54

Museum of the Confederacy, Richmond, Virginia 27, 36-37, 77

Nawrocki Stock Photo 113

The New York Historical Society 52-53

The New York Public Library 35 (top & bottom), 59, 64, 76, 78, 90, 96

The Newark Museum, New Jersey 50-51

Ohio Historical Society 104-105

Philadelphia Museum of Art, Pennsylvania 38, 45, 58

Picture Perfect 114, 115

Putnam County Historical Society, Cold Spring, New York 12

Seventh Regiment Fund, Inc., New York 100-101

The Union League Club of New York 98

U.S. Naval Museum, Annapolis, Maryland 68

Virginia Historical Society, Richmond, Virginia 22

Virginia Military Institute Archives 97

Wadsworth Athaneum, Hartford, Connecticut 17, 124-125

The Warner Collection of the Gulf States Paper Corporation, Tuscaloosa, Alabama 7

West Point Museum Collections, U.S. Military Academy 4, 46-47, 65, 106

The White House Collection, Washington, D.C. 18-19, 40-41

Yale University Art Gallery, New Haven, Connecticut 24-25

Contents

Introduction

Between April 12, 1861, and April 9, 1865, the United States of America underwent a violent cataclysm more tragic than any other event in the nation's history. For four years, Americans fought and killed each other on their own soil, all in the cause of determining the political, economic, and social shape of the nation. The divisive war affected virtually everyone in all parts of the country.

Some of America's most passionate feelings about the Civil War were expressed by visual artists, who worked assiduously during the con-

flict to render images of the war in sketches, paintings, and photographs. These pictures reflected the nation's most treasured ideals of democracy and individual accomplishment and the challenges to these ideals presented by the horrors of civil war. After the war, visual artists continued to produce related images that attempted to help the cause of national reconciliation—sketches, paintings, photographic collections, as well as monuments and other memorials.

The works of visual art engendered by America's Civil War are the focus of this volume, portraying many of the finest and most significant pictorial and sculptural representations in existence of this singular conflict, as well as presenting the lives and personalities of the artists and the extraordinary conditions under which some of their works were made.

The Great Cataclysm

During the four terrible years of this monumental struggle—known variously as the War Between the States, the War of the Secession, the War for Southern Independence, or the War of the Rebellion—millions of citizens took up arms against one another on a scope so enormous that

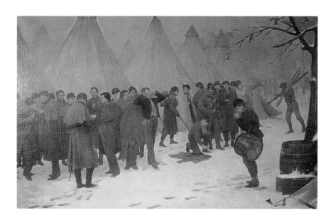

Reveille on a Winter Morning

HENRY BACON *n.d.; oil on canvas.*

West Point Museum Collections, U.S. Military Academy.

Daybreak drives men of the Army of the Potomac from their tents at a training camp outside Washington. A black orderly hauls wood as white soldiers yawn, pull on their clothes, and light cigarettes during roll call. On this snowy morning, a drummer boy blows on his hands for warmth.

The Consecration, 1861

GEORGE COCHRANE LAMBDIN *1865; oil on canvas.*

Indianapolis Museum of Art, Indiana.

In a moment of symbolic devotion, she kisses his sword as he kisses her rose before he departs for the front. Sweet thoughts will sustain them in their separation. Such sentimental images spoke to the hearts of the people who underwent the pain of the Civil War.

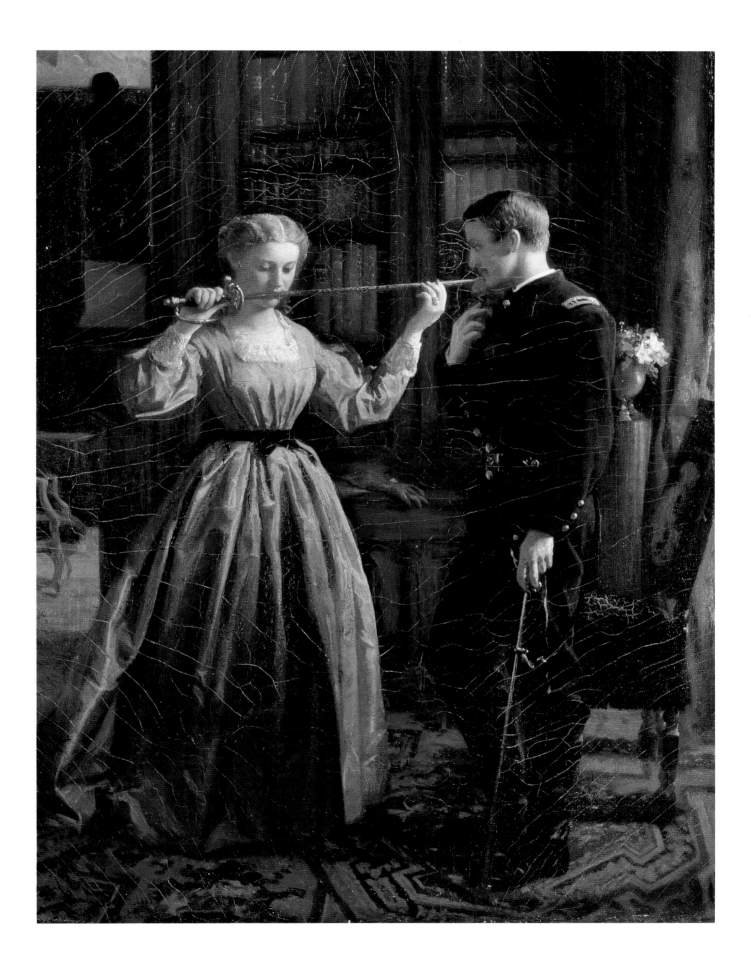

Death of Ellsworth

ALONZO CHAPPEL *c. 1862; oil on canvas. Chicago Historical Society, Illinois.*
In the first well-noted encounter of the war, Corporal Francis
Brownell crosses arms with innkeeper James Jackson, who
has just shot Colonel Elmer Ellsworth, transfixed against the
wall as his life ebbs away. Clutched in Ellsworth's hand is the
Confederate flag he has just torn from atop Jackson's inn.
Chappel was a prolific painter and book illustrator.

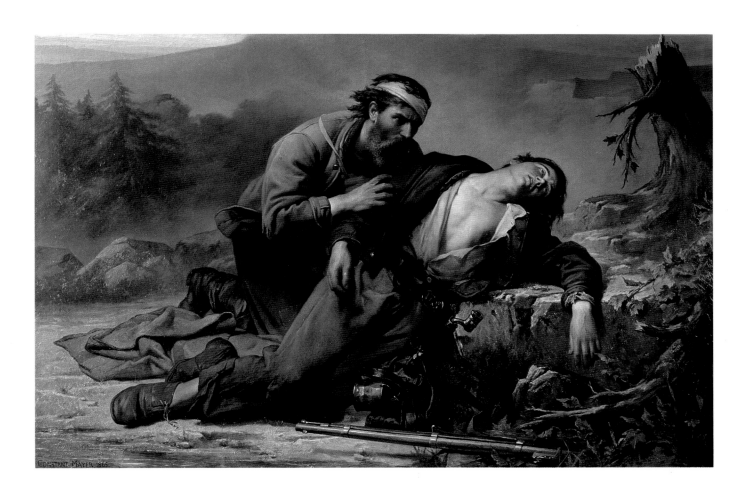

Recognition

CONSTANT MAYER *1865; oil on canvas. The Warner*

Collection of Gulf States Paper Corporation, Tuscaloosa, Alabama.

The Civil War frequently divided families and
ended friendships. In this dramatic scene, a
man in Confederate gray discovers that a dying
Union soldier is an old friend or, perhaps, a kinsman.

FOLLOWING PAGE:
Departure of the Seventh Regiment

GEORGE HAYWARD *1861; pencil, watercolor, and gouache. Museum of Fine Arts, Boston.*

In an optimistic display of enthusiasm, New York's Seventh Regiment
marches in colorful formation to answer President Lincoln's call for
troops to fight for the Union cause. Such upbeat portrayals were more
typical of the beginning of the war than later in the harrowing conflict.

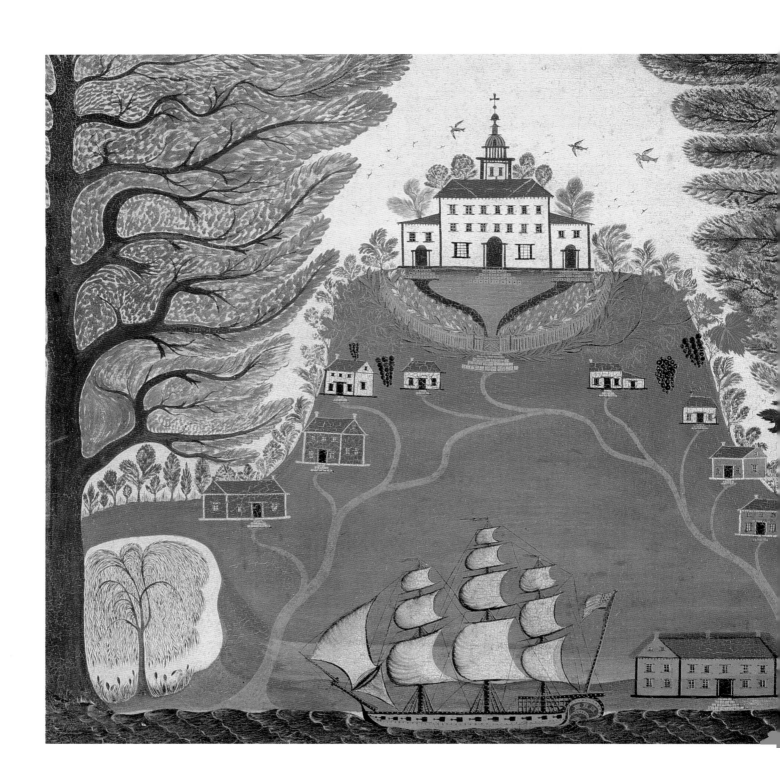

an estimated 620,000 people lost their lives—a number far greater than in any other conflict in which Americans have been engaged. (In comparison, 405,400 Americans died in World War II.) The North lost more than twice as many as the South.[1]

A great turning point in the history of the United States, the war swept over the land as members of hundreds of thousands of households joined the battles, suffered deprivations, and grieved for their loved ones. All parts of the nation were affected—some physically assaulted by battles and skirmishes, others by the vast economic and social forces unleashed by the conflict. No portion of the United States could remain disinterested; indeed, fascination with the war was overwhelming throughout the country and abroad.

At stake was the very body of the nation—whether it would remain a united entity or split into two or more sovereign countries. The states of the Confederacy had seceded from the Union; the forces of federalism, however, would not allow it. Also at stake was the fate of the slaves—prisoners and their descendants who had been kidnapped and brought from Africa against their will to serve those and their descendants who had voluntarily migrated to the New World from Europe. Northerners—particularly those with no economic involvement with enslaved people—cried out for the abolition of slavery, while Southerners—especially those whose livelihoods depended upon the labors of slaves—insisted upon their rights to own the bodies and services of other human beings.

The war began at a time when great social and technological changes were taking place

The Plantation

UNKNOWN ARTIST *n.d.; oil on canvas. The Metropolitan Museum of Art, New York.*
In this delightful painting, the orderly structure of a plantation is optimistically portrayed. The grand home of the owners rises above the cabins and cottages of the workers, while a boat awaits a shipment of the plantation's bounty—luscious fruits and, presumably, cotton.

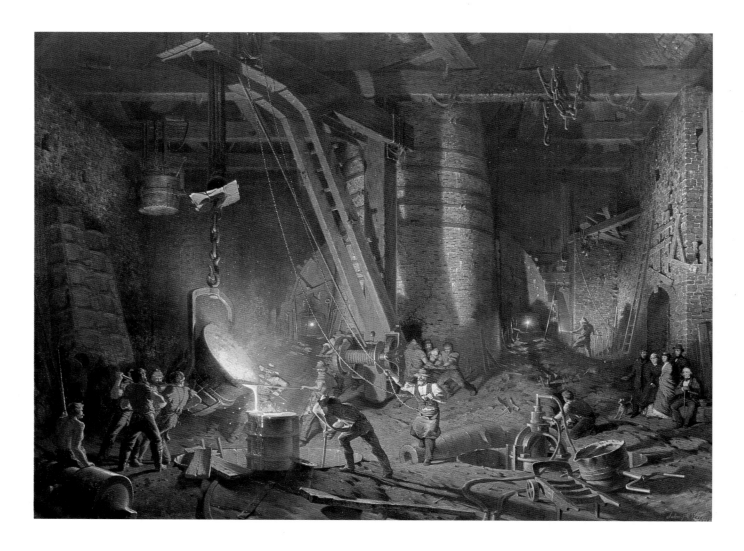

The West Point Foundry

JOHN FERGUSON WEIR *1866; oil on canvas.*

Putnam County Historical Society, Cold Spring, New York.

Industrial might is celebrated in this depiction of the
bustling West Point Foundry, where huge Parrott guns—
which fired up to 250-pound projectiles—were cast.
The guns were used by both the Union Army and Navy.
The military strength of the North depended greatly
upon its industrial economy, a key element in its victory.

Writing to Father

EASTMAN JOHNSON *1863; oil on canvas. Museum of Fine Arts, Boston.*

A child's concern for his father far away on the battlefield is
shown in his concentration as he pens a letter in a childish
hand. He wears a little soldier's uniform, his kepi on a nearby
chair. Letters kept love alive, moving slowly by mail between
worried families and homesick fighting men. Through his use
of soft sunlight, Johnson conveys the warmth of family feelings.

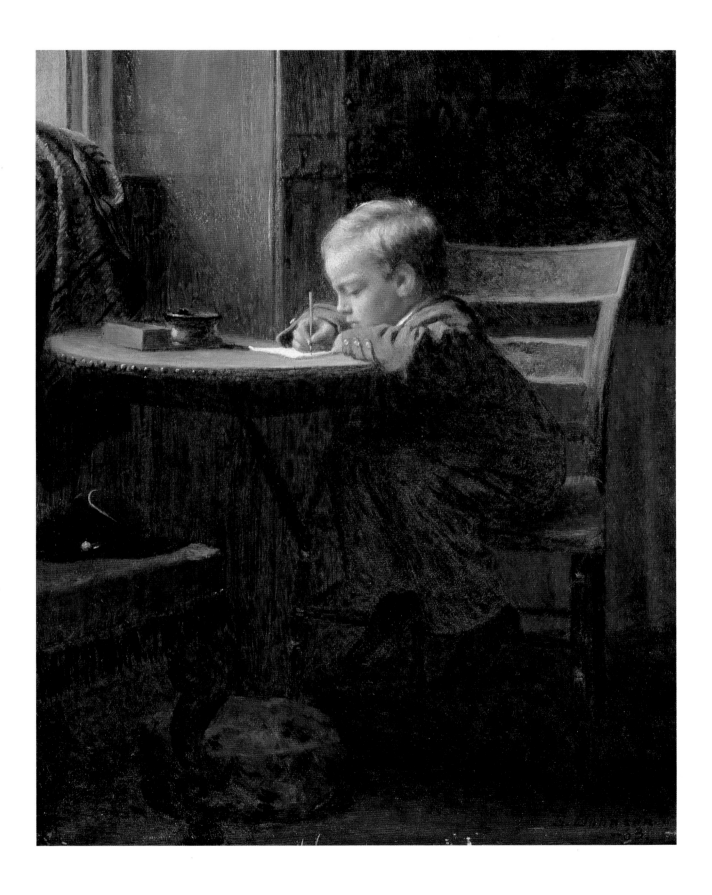

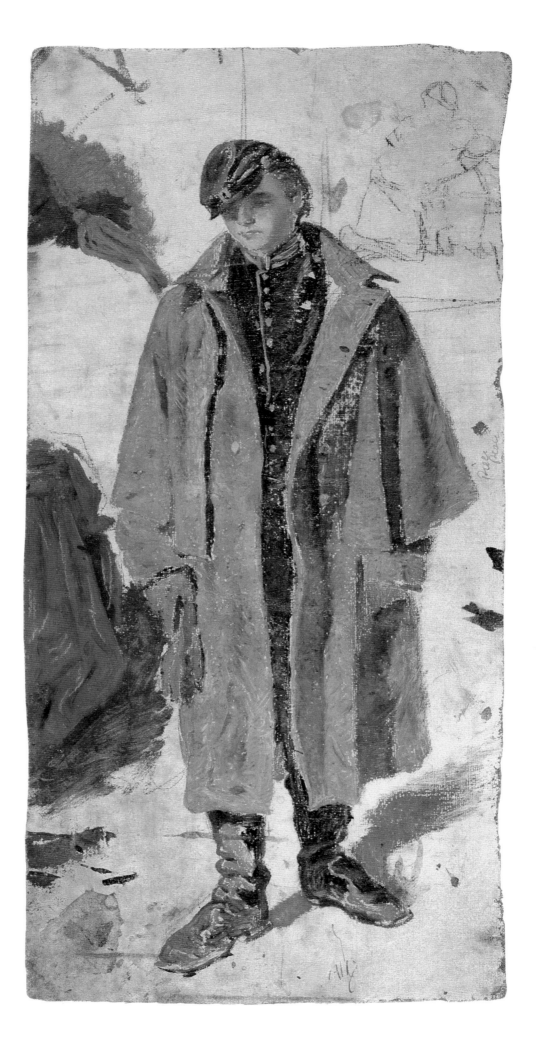

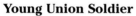

Young Union Soldier

WINSLOW HOMER *c. 1864;*

oil, gouache, and pencil on canvas.

Cooper-Hewitt,

National Design Museum, New York.

A young soldier stands
pensively, his shoulders
stooped with a coat and respon-
sibilities too great for one his
age. In camp, youths were
assigned cooking and cleanup
chores, and on the battlefield
acted as drummer boys and
assisted in burying the dead.

throughout much of the Western world. In many nations new experiments in government, especially democracy, were being employed. Novel developments in military equipment, transportation, and strategies were becoming available. The American Civil War proved to be a trial by fire in which many of these innovations could be tested and shaped, affecting the social, economic, and technological institutions that would develop afterward.

Images of the Conflict

When the war began, and as events continued to unfold for the following four years, Americans were well aware of the significance of the conflict on all levels—national, local, and personal. The demand for news of the war was overwhelming.

The public wanted to know all about it, and appetites grew for reports and illustrations. Simple texts without images were shunted aside in favor of lively accounts invigorated by graphic scenes of significant events happening thick and fast. The Civil War became the first great media event in American history.

Popular periodicals rose to meet the challenge of informing the populace and, in addition, cashed in on the opportunity to dramatically increase circulation. *Harper's Weekly* had been founded in 1857 in New York and in just four years commanded a circulation of 120,000. It was destined to become the greatest pictorial newspaper of nineteenth-century America. Among *Harper's* competitors were *Frank Leslie's Weekly* of New York, the *New York Illustrated News,* and

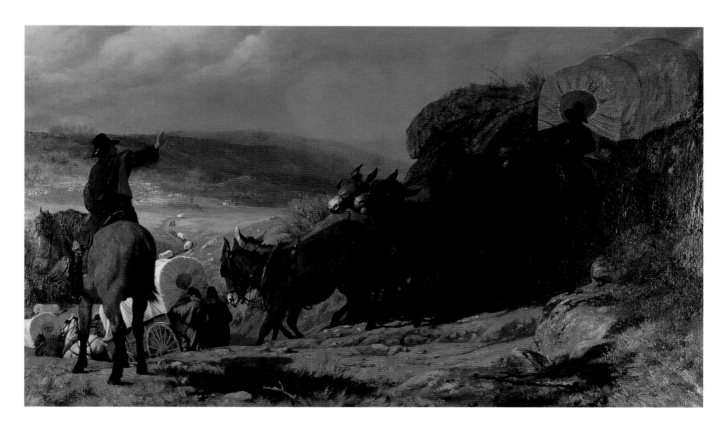

Wagons in the Shenandoah Valley

JOHANNES A. OERTEL *1866; oil on canvas. Fenton Historical Society, Jamestown, New York.*
Supplying the armies of the Civil War was no small feat. Blacksmiths, saddlemakers, carpenters, and cooks traveled by wagon over roads that were little more than rough rutted trails. Here, a Union army teamster struggles to control his mules on a downhill slope.

Boston's *Ballou's Pictorial Drawing-Room Companion*, with a circulation of over 100,000. *The Illustrated London News* also had many readers eager to learn of developments in Britain's former colony.

Each of these publications hurried to dispatch reporters to the war zones, and along with them went illustrators assigned to depict the events as they happened before their eyes. These professional visual reporters and many other graphic artists worked with pencil, pen, ink, chalk, and paint to produce a striking pictorial record of the war's participants and events.

At the moment the Civil War erupted, the new technology of photography was also emerging; this war in fact was the first major conflict to be substantially recorded by camera. The drama of the war inspired photographers to tremendous efforts in reproducing images of the struggle on glass and paper. For the first time in history, people far from the front lines could see reasonably accurate representations of the faces of the combatants and what they were experiencing. Photography would revolutionize for all time accessibility to a multitude of history-shaping images, and the Civil War gave this new art form an explosive boost at virtually the moment of its birth.

Most of the combat artists and photographers were of Northern origin and followed the federal forces, although a good number accompanied the Southern armies. Whichever side in the conflict they favored, they were remarkably neutral in their portrayals, reporting events as they saw them and doing their best to show frailties and virtues on both sides.

Great leaders emerged, and their actions were well documented. Abraham Lincoln, the small-town lawyer who struggled to lead the nation during its most difficult period, found eloquence, character, and deep sensitivity within both himself and his countrymen. Today his reputation is that of America's greatest president. General Robert E. Lee, the stalwart soldier who led the military forces of the Confederacy, ended the conflict with his honor burnished bright for the ages. The faces of these great men were well known to their compatriots and are familiar to us now through the numerous images that were made of them during this time.

Technical limitations in reproducing works of art meant that nineteenth-century readers of illustrated publications could not see the actual images the artists produced, either in black and white or color. Neither photographs nor sketches could be widely reproduced without utilizing an engraver, a middle-man who translated original images into plates for the printing presses of the day. Color reproduction was not possible, except as stenciled-in color on engravings or lithographs. Color photographs did not exist, and oil paintings or watercolors, no matter how finely done, were limited in their audience to those who could manage to attend an exhibition or purchase a painting for private perusal.

After the cessation of hostilities, continued interest in the Civil War encouraged artists and photographers to produce finely wrought versions of battle sketches, detailed paintings, and display albums with individually tipped-in photographic prints. Painters collaborated in producing elaborate murals of major battles, and the public flocked to see these. Monuments to Civil War figures and events, along with museums of war memorabilia, sprouted all over the country, and vast numbers of books filled with texts and illustrations on the war appeared—and continue to appear.

Today, more than a hundred and thirty years after the guns fell silent on Civil War battlefields, we are privileged to be able to see faithful reproductions of sketches, paintings, and photographs of the conflict. Through these images we can attempt to understand the profound tragedy that befell the United States between 1861 and 1865.

The best of American ideals of democracy and nobility are exemplified in the art of the Civil War. Common folk and people of exalted station meet in these compositions, their fates inextricably intertwined. Bravery, honor, honesty, mutual assistance, and the ability to overcome hardship are all admirably portrayed. These ideals, so strongly held in the past century, remain with us still. The pictures spoke eloquently to the people of the Civil War era, and they speak to our hearts to this day.

Fight for the Standard

UNKNOWN ARTIST *c. 1865; oil on canvas.*
Wadsworth Atheneum, Hartford, Connecticut.
The thrust of a sword draws blood as mounted soldiers battle for a regimental flag. These bright banners, symbolizing the unity and valor of their units, were highly coveted war trophies. Painters also loved battle flags; they add bright swatches of scarlet to many Civil War pictures.

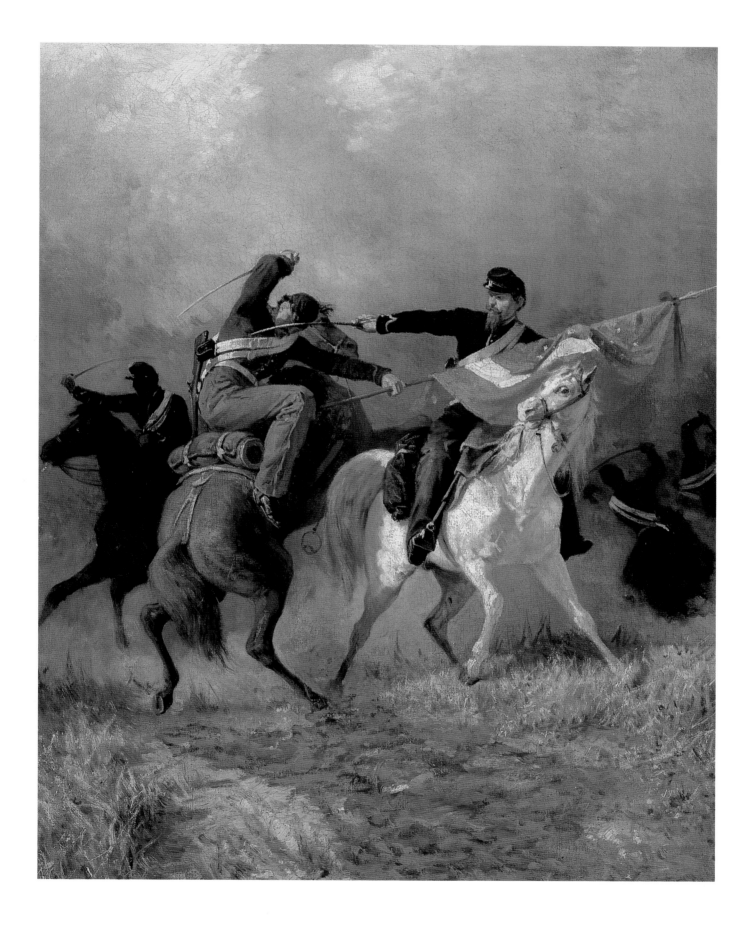

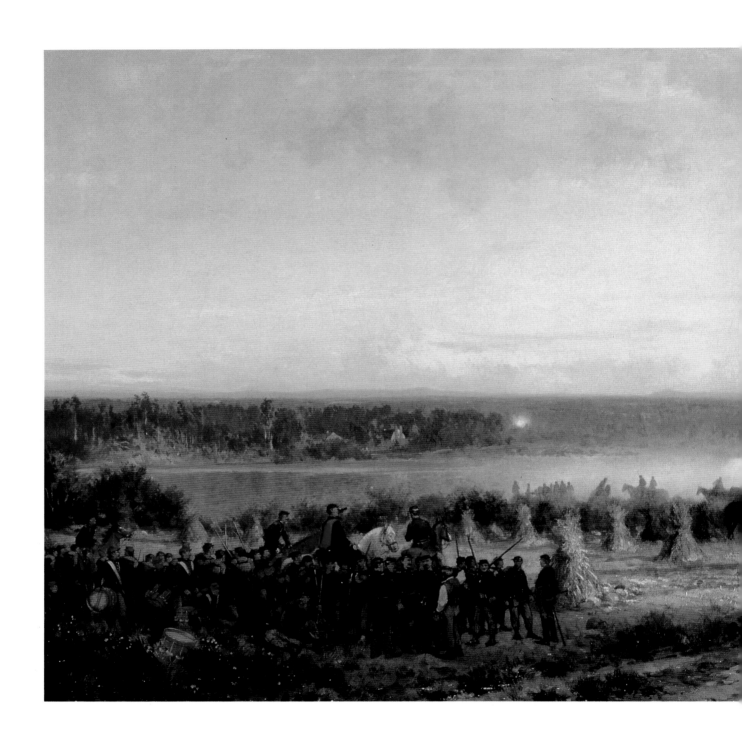

Artillery on the Potomac

A. WORDSWORTH THOMPSON *1861; oil on canvas. White House Collection, Washington, D.C.*
Autumn light warmly illuminates shocks of corn and russet foliage in
this work, as puffs of smoke bespeak human violence in the other-
wise peaceful landscape. In an exchange of fire across the Potomac,
Federal batteries in Maryland shell Confederate forces in Virginia.

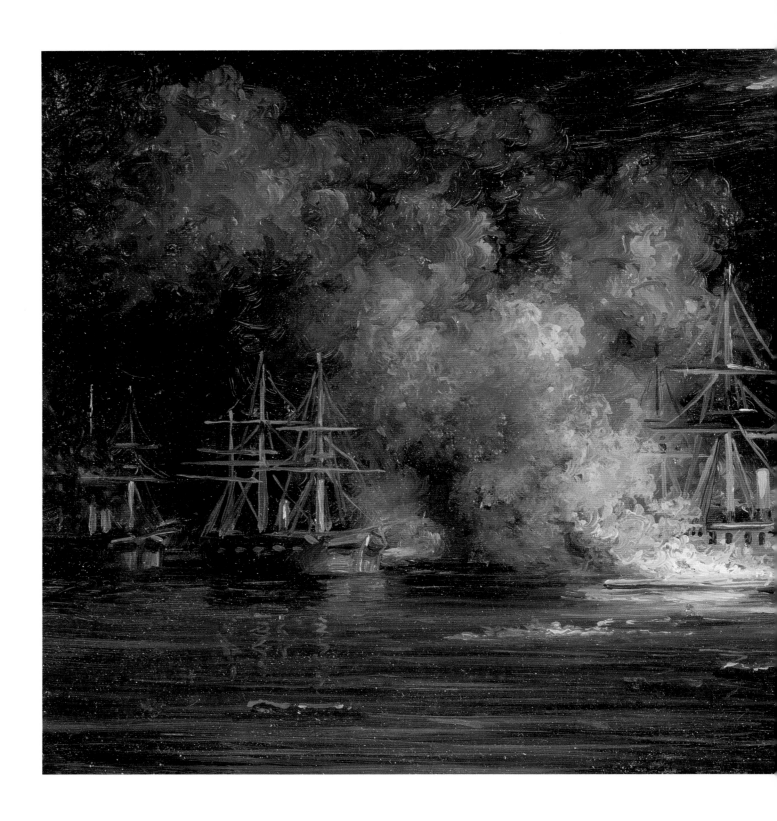

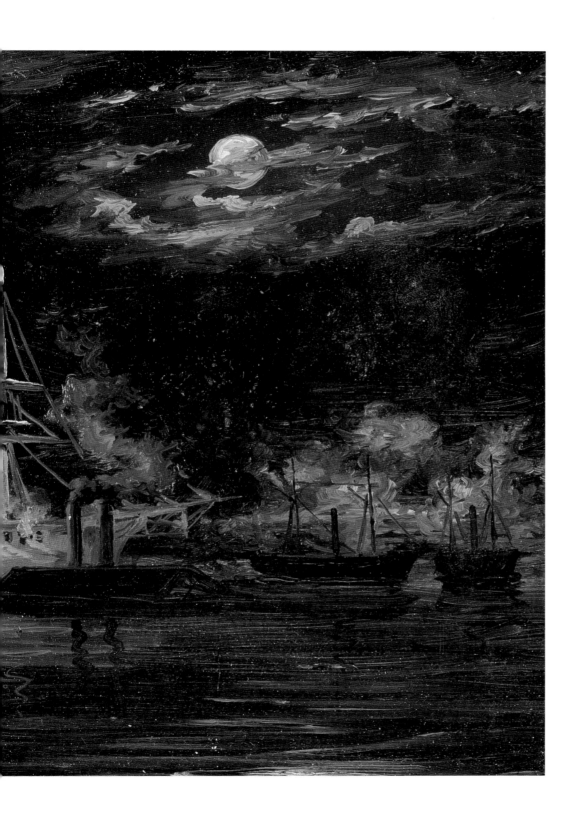

**A Fire Barge
in New Orleans
Harbor,
April 24, 1862**

XANTHUS R. SMITH *n.d.;
oil on paper. Courtesy
Robert M. Hicklin, Jr., Inc.,
Spartanburg, South Carolina.*
A raft of fire, pushed
forward by a
Confederate ram,
comes inexorably
toward Union
Admiral Farragut's
flagship in the New
Orleans harbor.
The hellish barge
engulfed the ship
in flames, which the
Union sailors man-
aged to douse, how-
ever, before they
proceeded toward
New Orleans itself.

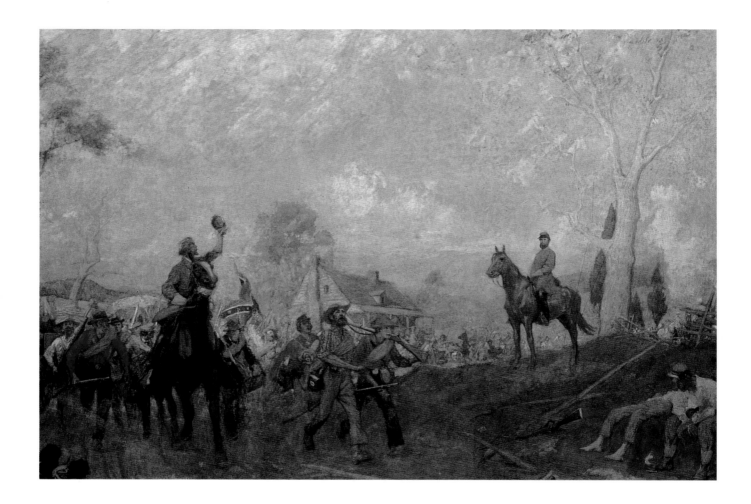

Cheering Stonewall Jackson

CHARLES HOFFBAUER *1861; oil painting. Virginia Historical Society,*
Richmond, Virginia.

General Thomas "Stonewall" Jackson was greatly admired by
both his men and fellow commanders alike. Here his exhausted
troops, marching past their commander in the Shenandoah
Valley, take time out to cheer him. The Confederacy was
blessed with some excellent and charismatic military leaders;
the Union had to search to find comparable commanders.

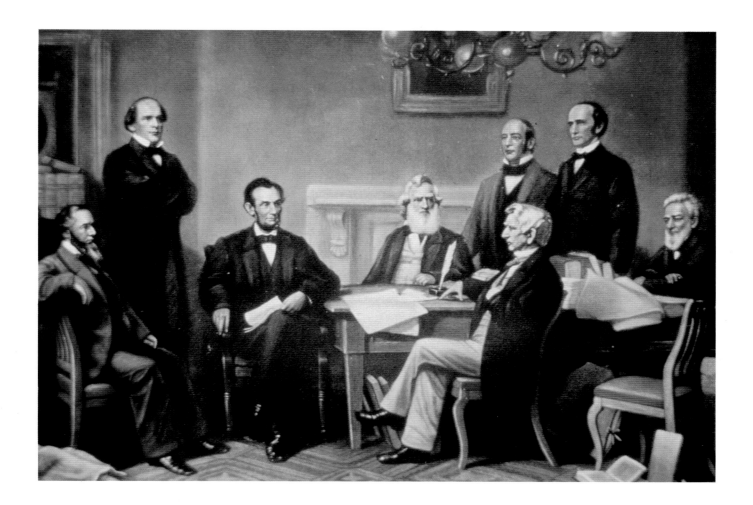

**First Reading of the Emancipation
Proclamation of President Lincoln**

Chromolithograph, after a painting

by FRANCIS BICKNELL CARPENTER *1864. U.S. Capitol, Washington, D.C.*

Surrounded by his cabinet, President Lincoln discusses with them his
proposed Emancipation Proclamation, which elicits cautious doubts. The
artist worked on his painting of the historic moment for six months,
studying and painting from portrait photographs to produce this realistic
yet stiff composition, which attained great popular and financial success.

In Front of Yorktown

WINSLOW HOMER *1862; oil on canvas. Yale University Art Gallery, New Haven, Connecticut.*

The radiance of firelight shines through the trees as men on picket duty cluster
around a campfire in the Virginia woods. The solemn beauty of this nocturnal moment
is masterfully captured by the artist, who traveled with the army early in the war.

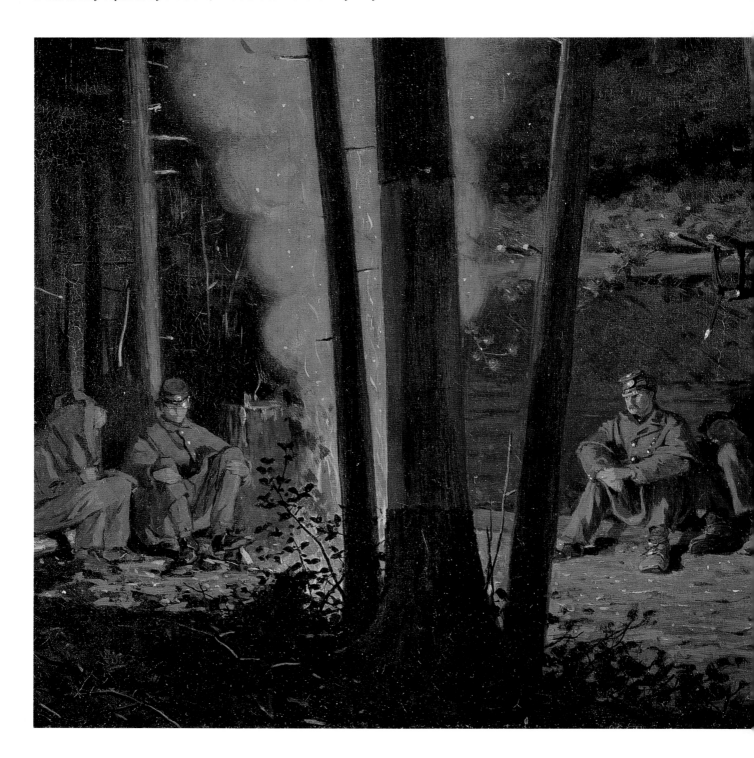

Drawing and Painting the Civil War

With the outbreak of the Civil War, many publications sent reporters and correspondents to the war zones to gather information and write stories for the press. In addition, the illustrated publications dispatched some twenty-eight "special artists" (artists on special assignment) to the front and behind the battle lines to prepare sketches of events as they unfolded. This visual reporting, along with the efforts of photographers and several hundred amateur artists, allowed millions of Americans to envision the most dramatic events of the war.

The correspondents and artists enjoyed amazing freedom of movement and were virtually uncensored in what they could observe and reveal. For example, William H. Russell, a well-known correspondent of the *London Times*, was welcomed by politicians and generals throughout the South, where he visited military camps and fortifications and freely wrote about what he saw. It has been said that newspapers, at least in the early days of the war, made espionage practically unnecessary.[2] Indeed, Union and Confederate soldiers often sought to obtain newspapers from one another, both by trade and by capture, in order to know what was going on not only on the home front but in the military zones.

The opportunities for adventurous artists were enormous, and hundreds found their way into

every zone of the war. Their pencils and pens dashed quickly over sketchbook pages, hastily producing images of the conflict, its participants, and the scenery. Working alongside the sketch artists were photographers, honing their skills in their new and technically limited endeavor. The artists' pictures were dispatched by mail and messenger, either overland or by ship, back to the waiting editors, engravers, and printers, who rushed to include them in the illustrated news. These war-time illustrations both reflected and shaped the great cultural and historical events of the era.

Artistic Trends in Mid–Nineteenth– Century America

Since colonial times, American culture had been the meeting ground of two forces—a strong, homegrown emphasis on self-sufficiency, together with a lingering pride in and admiration for European cultural traditions and fashions. The interaction of these forces was very evident in the development of drawing and painting in mid-nineteenth-century America.[3]

The American sense of the artist's place and purpose in society was undergoing dramatic change in the decades before the Civil War. Once, the accepted purpose of painting had been to please and uplift by presenting objects and themes of inherent beauty, creations intended to arouse feelings of pleasure and fine sentiment. Now, however, a sense of the importance of reality was gaining ground. The new idea was that art should instruct through representations of the Real—the actual surroundings and conditions of American life—rather than through idealizations of classical European themes.

These distinctions clearly reflected political and economic conditions. The United States had, in fact, politically separated itself from European domination and was moving toward becoming a significant world economic power. Old World aristocratic notions were rejected in a nation increasingly composed of hard-working farmers, townsfolk, and frontier dwellers.

Folk artists, craftspeople, and naive "primitive" painters abounded. Some notable artists focused on American plants, wildlife, and birds, and a number of painters stressed Native American themes. Political cartoons ridiculing the antics of politicians were popular. Old-style artistry remained, to be sure—a few elegant painters of the American aristocracy preferred European-influenced painting styles. Yet also gaining in popularity were melodramatic images of man's eternal struggle with Nature and Fate, particularly dramatic when set in the American landscape.

As the nineteenth century progressed, a new appreciation arose for rugged American vistas. Images of human figures romantically contemplating nature's wonders, and pictures of awe-inspiring rivers, cliffs, waterfalls, and mountains were admired. As the eastern portion of the country became more settled, easterners began to think of the wilderness with nostalgia.

The Hudson River School of painters was clearly influenced by Europeans—in fact, an English-born painter, Thomas Cole, is credited with starting the movement in about 1825, with three luminous canvases of Hudson River scenery. But the Hudson River painters' strength was in portraying the particular beauties of recognizably American landscapes. For many, such paintings were visual sermons—viewing the American land was a way to perceive God through his majestic natural works.

By the 1850s American art was making clear democratic statements. Much appreciated were George Caleb Bingham's paintings of folk-hero types, such as earnest stump speakers surrounded by small-town folk and Missouri steamboat cargo handlers resting with almost biblical dignity. The unspoken standard seemed to be an unpretentious and honest representation of reality. Currier & Ives lithographs, extremely popular throughout much of the century, unstintingly portrayed the delights of simple American life.

The expansion of photography in the United States also added to the appreciation of representations of reality. More than any form of art form previously known, photography offered realistic images of people and places. Photographers roved the nation, carrying their darkrooms with them in horse-drawn carts, or traveling along rivers on flatboats, bringing photography to ordinary people almost everywhere. In American photography, as in painting, not only the high-born

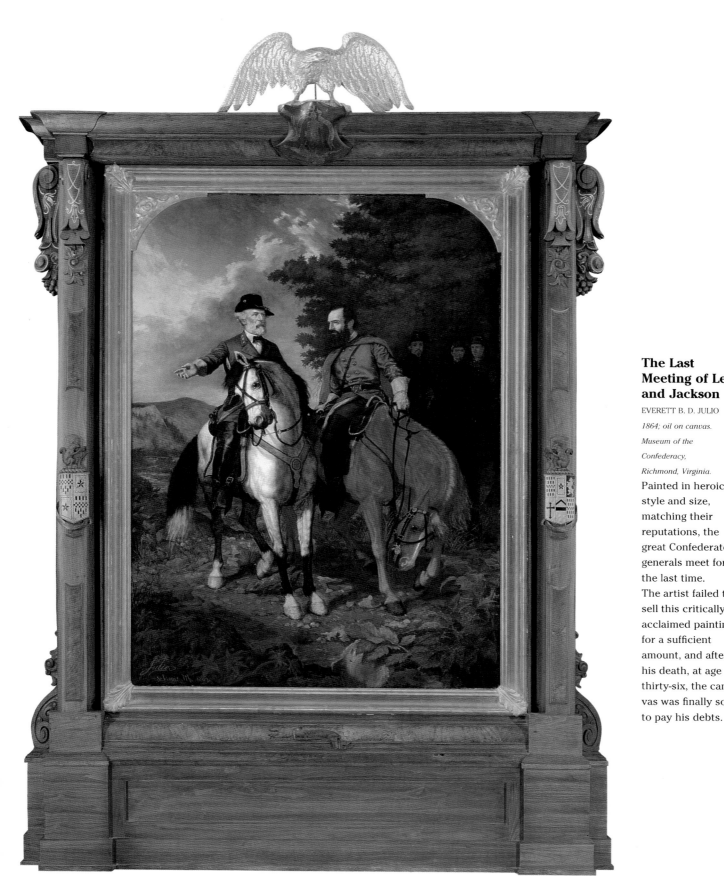

The Last Meeting of Lee and Jackson

EVERETT B. D. JULIO

1864; oil on canvas.
Museum of the
Confederacy,
Richmond, Virginia.

Painted in heroic style and size, matching their reputations, the great Confederate generals meet for the last time. The artist failed to sell this critically acclaimed painting for a sufficient amount, and after his death, at age thirty-six, the canvas was finally sold to pay his debts.

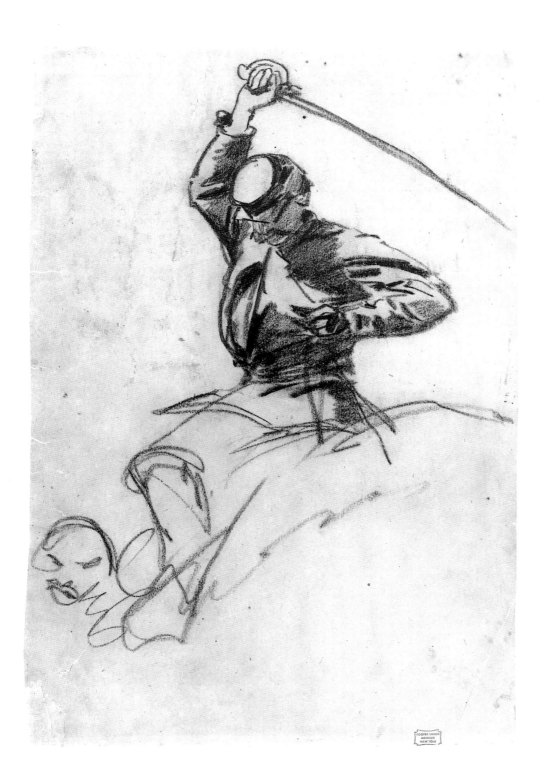

Cavalry Soldier on Horseback

WINSLOW HOMER *c. 1863; crayon on paper.*

Cooper-Hewitt, National Design Museum, New York.

Swift of sword, the cavalry soldier slashes at
his enemy in the thick of combat. Homer caught
the action with quick strokes of his drawing crayon.

were represented, but the common folk and their lives were legitimate subjects of the artist's attention.

The Civil War shattered the self-assuredness of American culture and its artistic standards, and, after the war, American art became more varied, even as the country itself branched out, politically and economically, in many directions.

In the Field

When the war began in earnest, there was a great demand for artists to fan out over the many scenes of action. Their hastily-rendered works of art were often created under the most trying conditions, with bullets and cannon balls flying dangerously close by. Furthermore, trying to find a viewpoint from which to see the action was often all but impossible. Their work would later be judged not only for accuracy but for artistic merit. A more difficult practical art exam could hardly be imagined.[4]

In a set of drawings published in *Harper's Weekly* in 1864, artist Thomas Nast portrayed "The Press in the Field." In one picture, the artist, astride a horse, holds his sketch pad up as he draws a battle raging before him. On the ground, just inches from his horse's hooves, lies a dead soldier—an acute reminder of the fate that could await an unlucky member of the press. In fact, one artist was killed and another severely wounded during the course of the war. For the tribulations they

faced, these talented men were paid reasonably well. Some were on salary, but others received from $5 to $25 per picture—the equivalent of about $100 to $500 today. After the end of the war, *Harper's* paid tribute to the men who had risked their lives to provide pictures for the edification of all.

The artists personally faced the realities of the Civil War on a daily basis, and, for the most part, were well-versed in the artistic values of the time, emphasizing the importance of a realistic approach. Their sketches reveal their efforts at portraying what they saw—faces of recognizable people can be seen among the groups of soldiers fighting and dying in the sketches. Still, some romantic views of the war emerged in the drawings and paintings. Early in the war, while naiveté and enthusiasm were still high, coverage sometimes focused on dramatic gestures, such as officers riding grandly to battle. Later, as the crushing tragedy of the war brought spirits low, pictures necessarily placed more emphasis on less heroic and idealized moments.

Early illustrations displayed a tendency among some artists to portray lines of soldiers advancing in neat rows, as in many conventional European paintings. Later, when such ideals were clearly shown to be absurd—in life as in art—artists felt more freedom to depict the disorderly facts of warfare, such as combatants advancing, retreating, and falling in a helter-skelter of formations, their limbs entangled with underbrush and branches.

When a camera records a scene, it is difficult to efface reality. In a photograph, dead bodies look grim and sad beyond measure. In a painting, there is at times a tendency to clean things up—to make the corpses look more like slumbering heroes than mutilated men, and to make the shattered soldiers seem more like actors than victims of a savage dispute.

For both photographs and sketches made in the field, pigment was a limitation. Most battle sketches and paintings were rendered in black and white, since reproduction in magazines and newspapers was possible only in those tones. Artists could not prepare finished paintings until they were well out of the battle zone.

There were a few full-color paintings made during the Civil War, especially watercolors, but also a few important oils. Many fine paintings made after the war were based upon wartime sketches and depict the scenes with a great deal of accuracy. Other colored images, however, produced during the war and afterward by artists who never saw action, contain a great deal of fantasy.

Drawing and painting brought something to the depiction of the war that no other medium could—a sense of motion. All photographs of the period were, in essence, time exposures, with no candid pictures of action. Drawings, like photographs, were still images, but, through careful selection of subject matter plus skillful use of line and shadow, artists could depict action and spontaneity. For images of a soldier shooting his rifle, being wounded, or charging into battle, the creations of the war's field artists were essential.

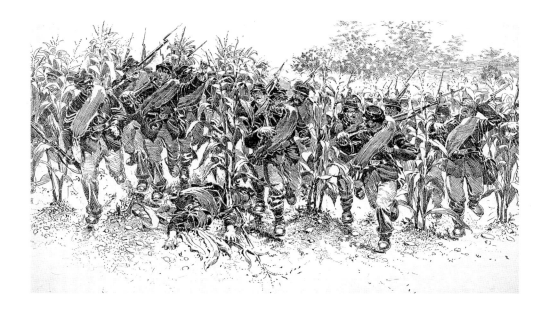

Union Charge Through the Cornfield, 1862

WALTON TABER *1886; ink drawing. American Heritage Century Collection, New York.*

Crashing through the cornfield at Antietam, Federal troops under the command of General Joseph Hooker attacked the Confederates.
The forces charged and countercharged, leaving hundreds dead among the smashed cornstalks.

A Variety of Artists

Answering the call to depict the war were artists from many backgrounds. Among these were native-born Americans, immigrants, trained professionals, and self-taught amateurs. Some were on the payrolls of periodicals, but others were strictly freelance. Some engaged full-time in their art work, while others were simply soldiers good with a pencil who sketched in stolen moments. As far as is recorded, virtually all of the field artists were men, of Euro-American or European extraction. The range of their talents was great, and together they created a marvelously rich body of work, much of which remains available to us today.

Winslow Homer, later to become a renowned painter, and Thomas Nast, who gained postwar fame as a political cartoonist, were the Civil War artists who ultimately became the most famous. Excellent as they were, however, they were not the most prolific artistic recorders of the war. That honor fell to men who are less well known today, but who devoted years of their lives to following the armies in the field.

Foremost among the prolific artists accompanying the armies of the Union were two English-born brothers, Alfred R. Waud and William Waud (pronounced Wode).[5] Alfred, particularly, gained recognition as the best special artist in the field. Born in London in 1828, he studied at the School of Design of the Royal Academy. After emigrating

to the United States in 1850, he became a newspaper artist in Boston and New York. When the war began, he was working for the *New York Illustrated News*, but in 1862 he began to cover the war for *Harper's*.

William Waud served as an assistant to Sir Joseph Paxton in the construction of the Crystal Palace, which housed Britain's Great Exhibition in 1851. He joined his brother Alfred in the United States and began his war coverage on the staff of *Leslie's*. In 1864 he too moved to *Harper's*.

Between the two of them, the brothers produced thousands of on-the-spot sketches, many of which have, fortunately, been preserved to the present time. Alfred drew detailed pictures of the fighting in Virginia, including scenes near Washington even before the First Battle of Bull Run in the summer of 1861, on up to the final phases of the Appomattox Campaign. A Mathew Brady photograph of Alfred at Gettysburg shows a good-looking bearded man in tall leather boots and a brimmed hat who is perched on a rock as he sketches. He was a well-liked, cheerful, hard-riding man.

William covered the war in the more western areas and in the far South, although he also spent time in the Carolinas and Virginia. He went to sea as well—an engraving from *Leslie's Weekly* shows William Waud sketching a naval battle from the U.S. war steamer *Mississippi*.

William Waud's adventures are less fully documented than Alfred's. Alf married and had four

The 1st Virginia Cavalry

ALFRED WAUD *1862; pencil and chalk drawing. The Library of Congress, Washington, D.C.*
The Confederate battle-flag flies proudly above mounted officers in this rare behind-the-lines view of crack Southern forces depicted by a Union artist. Waud entered the Confederate lines under a flag of truce, and his "polite and agreeable" hosts gave him a pass to return to the Federal lines in safety.

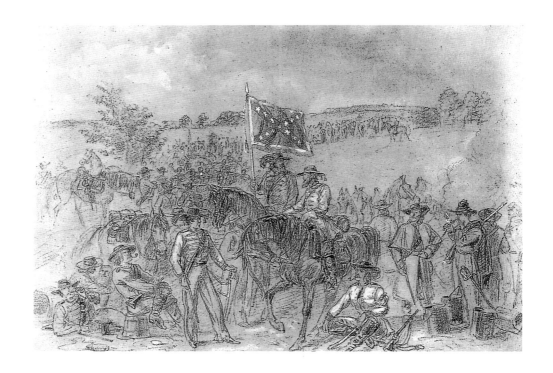

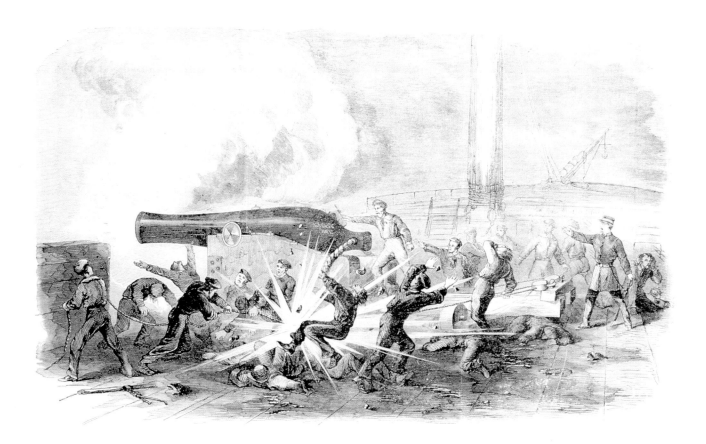

The Gunboat *Iroquois*

WILLIAM WAUD *1864; engraving.*

The Library of Congress, Washington, D.C.

The torments of war are vividly portrayed
by Waud as he shows a round of grape shot
tearing into a gun crew aboard the gunboat *Iroquois*.

children, but he seems seldom to have been at home. Instead, he risked his life on many battlefields and tramped and rode endlessly with the Army of the Potomac. Alfred sketched not only the Union army but also had a chance to portray the Confederates. "Detained within the enemy lines," in September, 1862, he made a fine pencil drawing of the 1st Virginia Cavalry, with the Confederate flag held proudly by a mounted officer. Alf Waud noted that their carbines were mostly captured from the Union cavalry, for whom they expressed "utter contempt."

In 1862, Alf Waud nearly died from malaria, and Will was felled by sunstroke. Along with McClellan's army on the Peninsula, the artists suffered "seven days almost without food or sleep, night and day being attacked by overwhelming masses of infuriated rebels thundering at us from all sides, and finally securing our position, utterly worn out, in a drenching rain, with a loss of nearly 35,000 men . . ." All the while, though, they were making brilliant sketches.

Later, at Gettysburg, Alf Waud produced the best drawings of that tragic campaign, making the only eyewitness drawing of Confederate General Pickett's charge, even as Edwin Forbes, the other special artist at Gettysburg, lost his nerve and

sheltered himself behind Cemetery Ridge.[6]

At Appomattox, as the war ended, Alf was the only sketch artist or photographer anywhere in the vicinity. He got there barely in time to record General Lee's departure from the scene of his surrender and the Confederates laying down their arms and battle flags. Later, he accompanied the Lincoln funeral train on its long journey back to Springfield, Illinois, and depicted the burial of the president.

Alfred went on a postwar tour of the South for *Harper's* and then traveled out West to report for various magazines and publishing projects. He worked up many of his battle sketches into more finished drawings for a major postwar publishing venture, *Battles and Leaders of the Civil War.* The extraordinary Waud Collection of drawings is now preserved in the Library of Congress.

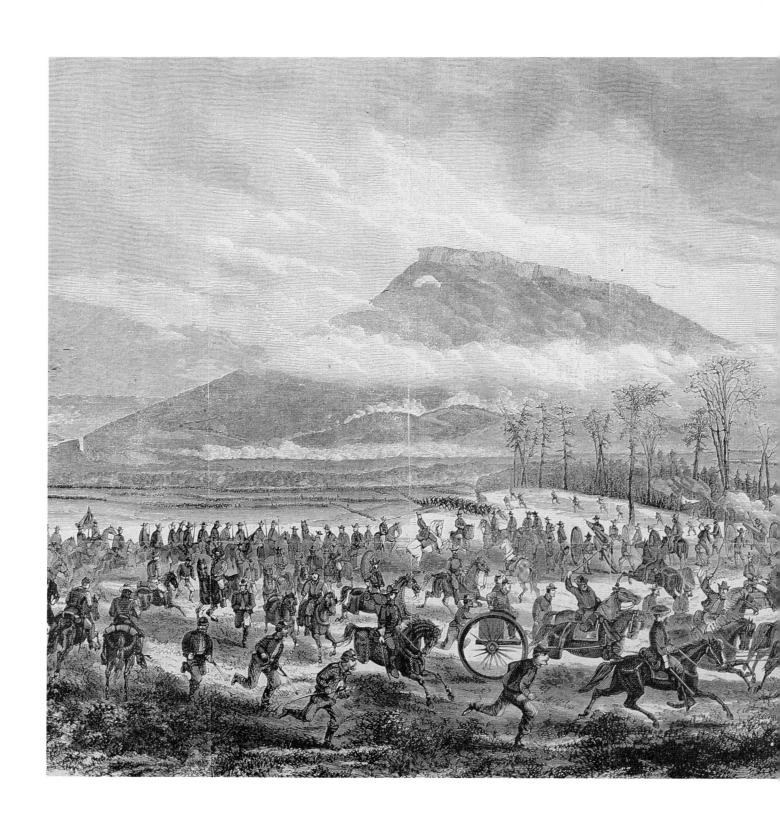

Sleeping with the Dead

Artist Theodore R. Davis, who had once been held for questioning while behind Southern lines, was especially noted for his detailed pictures of the campaign at Vicksburg, Mississippi. Born in Boston in 1840, Davis moved to Brooklyn in his teenage years, and probably had some art training before becoming a special artist for *Harper's Weekly* in 1861. He remained with *Harper's* for a total of twenty-three years. Of all the Civil War "specials," he was the most traveled. Frequently in the thick of the action, he was wounded twice, and once his horse was shot out from under him. At one point, his sketchbook was even shot out of his hand. Davis was gregarious and enthusiastic and won the respect of the fighting men with whom he traveled. Some of his drawings capture engaging anecdotes of the military life.

The drama of artistry at the front was revealed in Davis's recounting of a particularly memorable experience:

> One chilly night after the day of a hard battle, as I lay shivering on the ground with a single blanket over me, a forlorn soldier begged and received a share of the blanket. I awoke at daybreak to find the soldier dead, and from the wound it was plain that but for the intervention of *his* head the bullet would have gone through my own.[7]

After the war, Davis contributed extensive visual reporting from the Far West and the South. A state dinner service he designed graced the White House dining table, and he was historical consultant for major postwar paintings. He died in New Jersey in 1894.

The Battle of Lookout Mountain, 1863

THEODORE R. DAVIS *1863; engraving. The Library of Congress, Washington, D.C.*
One of the war's most adventurous artists, Davis was on the scene to record the Battle of Lookout Mountain on November 25, 1863. Though his original sketch of orderly troops moving toward chaos was hastily done, it was detailed enough to form the basis of this engraving, which subsequently appeared in *Harper's Weekly.*

On the Line

EDWIN FORBES *1864; engraving. Art Brown Collection.*
Men of the Union Second Corps are shown waiting
for the enemy at the Battle of the Wilderness,
May 10, 1864. Since Forbes traveled with the
troops, he knew firsthand the look and feel of war.

Edwin Forbes

Edwin Forbes of New York was employed by
Frank Leslie's Illustrated Newspaper, covering the
Army of the Potomac throughout the war. He once
commented that being a spectator at the great
battles of the Civil War was "nearly as dangerous
as being a participant." He was seldom afraid to
edge close to the action, and he was considered
especially energetic and daring. As shells and
musket fire crashed around his ears, he dashed
off quick sketches that he took back to his behind-
the-lines tent studio, where he added finishing
details to his beautifully rendered drawings. He
especially loved to portray artillery and cavalry
in the heat of action.

During lulls in the fighting, Forbes sketched the
common soldier's camp life. Some of his best
drawings were made during the Wilderness
Campaign, in Virginia in the late spring of 1864. He
wrote that his bluntly realistic renderings were
"too plain for misunderstanding and far too terri-
ble for any forgetting."[8]

Unlike most other artists of this war, Forbes
made a lifetime's career out of depicting the con-
flict. After the war he created a number of elegant
etchings and paintings, using his wartime sketch-
es as references. Many of his finest drawings are
now owned by the Library of Congress.

Going into Action (Cemetery Ridge, Gettysburg)

EDWIN FORBES *1863; etching.*
The New York Public Library.
The rush of a charge of mounted warriors gave inspiration to field artist Edwin Forbes. Skilled in drawing horses, he ably rendered these animals—so essential to the battles of the Civil War—in a variety of energetic poses.

Commissary's Quarters in Winter Camp

EDWIN FORBES *1863; etching.*
The New York Public Library.
The artist traveled with the army and was intimately acquainted with the details of army life and dress. Every soldier grew to know his equipment and his clothing well—he carried everything with him from camp to camp, over rough roads, in weather of all kinds.

Conrad Chapman

Conrad Wise Chapman[9] was raised in Rome by his father, John Gadsby Chapman, a well-regarded Virginia artist. When the war began, he hurried back to America and joined a Confederate regiment. At Shiloh in April of 1862 Chapman was seriously wounded in the head and was carried from the field in a lurching cart filled with other wounded and dying men. He was taken to a private house, where two women tended him until his recovery.

Chapman was transferred to a Virginia brigade, where he again saw action and made sketches that he later turned into etchings. In October, 1863, he was sent to Charleston, South Carolina, birthplace of secession, where, on order of General Beauregard, he made a celebrated series of thirty-one paintings of the harbor defenses during the long siege. The reckless Chapman sat sketching on the ramparts of Fort Sumter, with Union shells bursting overhead. In several striking paintings, prepared from his on-the-spot sketches, the tattered Confederate flag flutters proudly over Fort Sumter, destined not to be lowered until February of 1865.

Chapman also made hundreds of sketches of military life and portraits of soldiers. His work is considered the most important of Confederate contributions to the art of the Civil War and is treasured today in museums in Richmond, Virginia, where Chapman's life came to a close in 1910.

The Sunset Gun, Fort Sumter

JOHN GADSBY CHAPMAN, AFTER A SKETCH BY CONRAD WISE CHAPMAN

1864; oil on canvas. Museum of the Confederacy, Richmond, Virginia.

The Confederate banner flying bravely over Fort Sumter signaled heroism for the defenders of the fort where the Civil War began, but after twenty-two months of Union shelling, the flag was lowered and replaced by the Union banner that flew there four years earlier.

Other Confederate Artists

John Adalbert Volck, who sometimes signed his drawings "V. Blada," was another important Confederate artist. An immigrant from Germany, he was an ardent Southern sympathizer and was imprisoned in Fort McHenry in 1861. His drawings included satirical caricatures of Lincoln and General Benjamin F. Butler, who had had him imprisoned.

Allen Christian Redwood served throughout the war in the Army of Northern Virginia. Captured at the Second Battle of Bull Run and subsequently exchanged, he rose to the rank of major. He created an extensive body of Civil War scenes, which were published in books and magazines.

William Ludwell Sheppard of Richmond studied art in New York and Paris before joining the Richmond Howitzers. During his four years in the South-

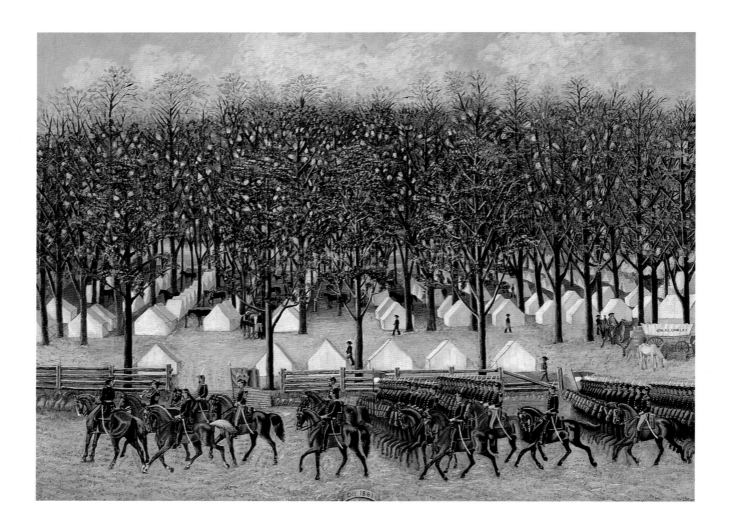

McClellan Drilling Troops

UNKNOWN ARTIST *1861; oil on canvas. Philadelphia Museum of Art, Philadelphia, Pennsylvania.*
The chaotic rout at Bull Run produced a determination to reorganize the Army of the Potomac. Union Commander-in-chief George McClellan's men, along with their horses, drill in neat rows, echoing the orderly lines of tents and trees. This charming representation conveys little of the messy, confusing realities of the war.

ern army, he made sketches in free moments, and his fine series of watercolors on life in the Southern ranks is now part of the collection of the Confederate Museum in Richmond. He was also a sculptor; his best-known sculptures are of Confederate heroes, also on display in his home town.

British artist Frank Vizetelly was so pro-Southern that General James Longstreet of the Army of Northern Virginia made him an honorary Confederate Army captain at Chickamauga. Some of Vizetelly's drawings made it across the ocean to *The Illustrated London News*, but others were captured by Union warships and pirated in the Northern press. After the war, his luck ran out—he went to Egypt and disappeared. He is believed to have been killed in a massacre in the Sudan or to have been sold into slavery—certainly an ironic fate for a Britisher who favored slavery in America.

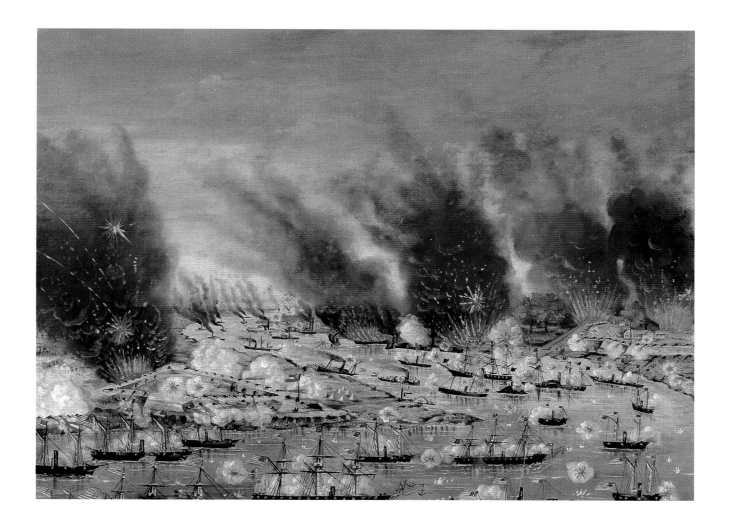

Farragut's Fleet, April 24th 1862.

J. JOFFRAY *n.d.; oil on canvas. Chicago Historical Society, Illinois.*
Bursts of brilliant light illuminate the night sky at New Orleans, as more than forty vessels led by Admiral David Farragut storm past two Mississippi River forts. The dazzle of death looks almost festive in this composition.

Reception at the White House

ATTRIBUTED VARIOUSLY TO EITHER
PETER F. ROTHERMEL OR
FRANCIS B. CARPENTER *c. 1867;
oil on canvas. White House
Collection, Washington, D.C.*

An idealized gathering of illustrious personages at the White House glows with magnificence at a grand reception in honor of Ulysses S. Grant's promotion to Lieutenant General. Lincoln, flanked by Grant, greets Mrs. Grant, while Mary Todd Lincoln attends to General Winfield Scott, seated. Actually, on this occasion, while Lincoln and Grant initiated a cordial relationship, Julia Grant and Mary Lincoln took an instant dislike to each other.

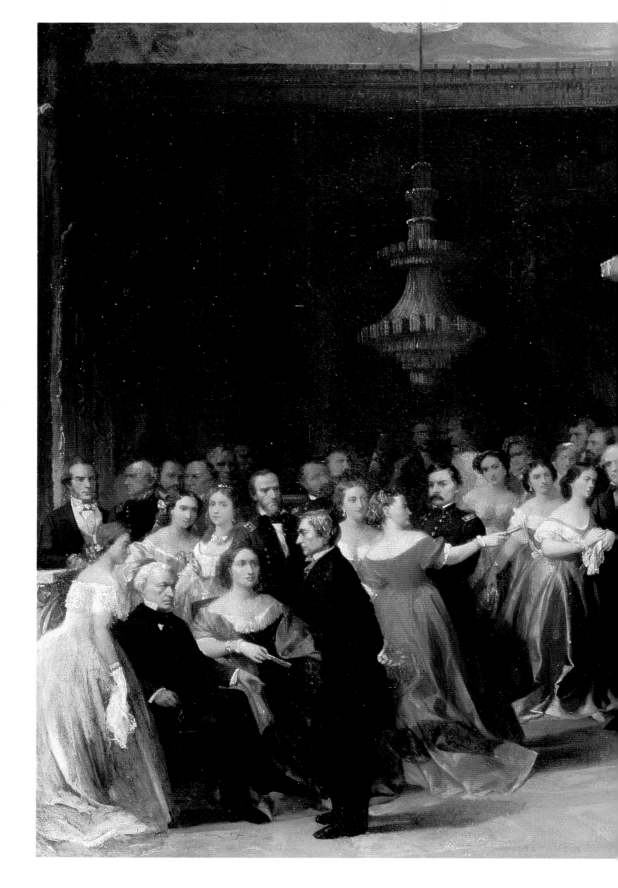

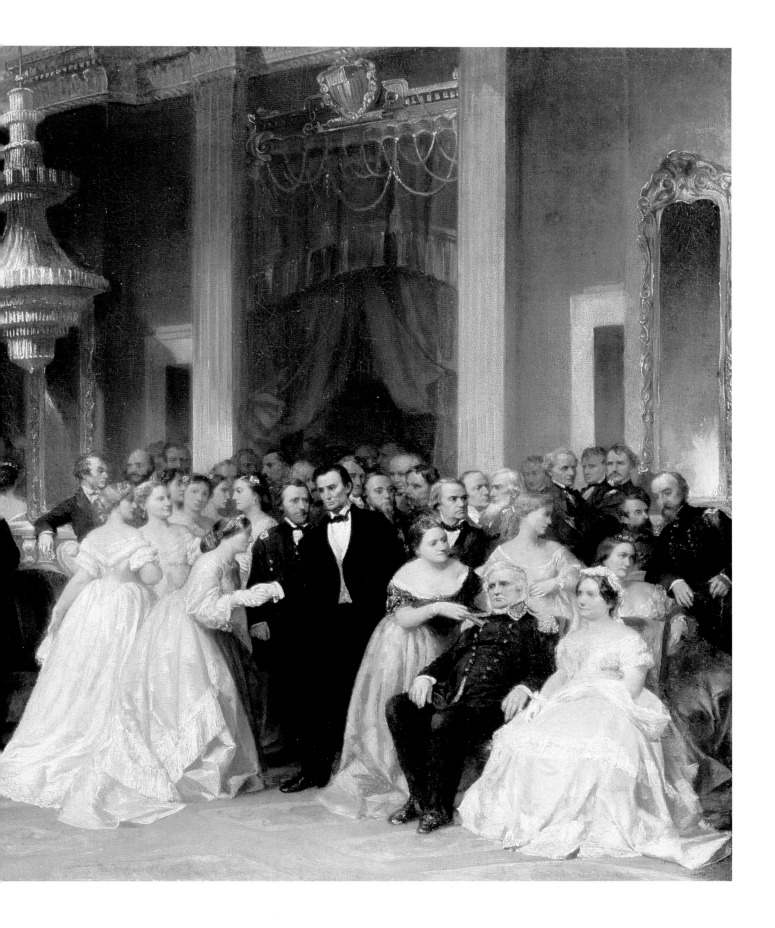

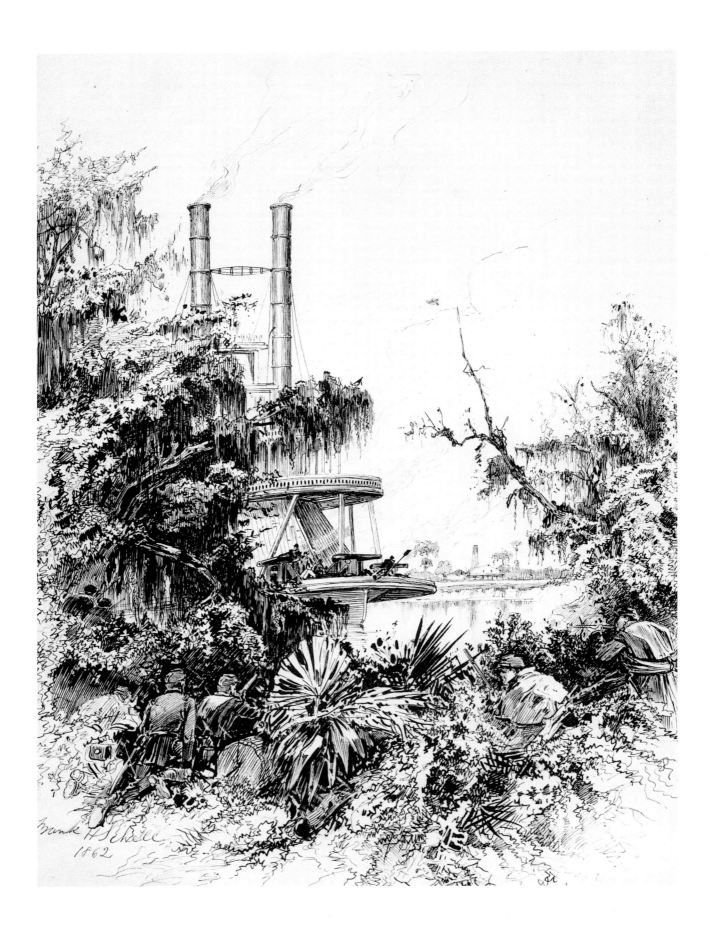

The Battle of Munfordville, Kentucky

HENRI LOVIE *1862; engraving.*

Art Brown Collection.

This image showing Confederate troops cutting into a Federal line demonstrates Lovie's flair for capturing violent action in a way that draws the viewer into the scene.

Sketchers and Painters

Many other artists of both North and South achieved distinction as they outlined images from all theaters of the conflict. Henri Lovie was the senior veteran of *Leslie's* corps of artists and covered McClellan's campaigns competently, even though Union soldiers once mistook him for a spy and almost killed him for it.[10] Other artists whom the illustrated papers employed to sketch included Arthur Lumley, Joseph Becker, Alexander Simplot, and William Crane. Additionally, there was William Shelton, a Union artilleryman captured in the Battle of the Wilderness. He made a daring escape, which he described and illustrated for *Century* magazine. H. E. Brown was an enlisted man in Union General Joseph Hooker's 12th Corps who sketched alongside Theodore R. Davis during the Chattanooga campaign. After the war, Brown became a portrait painter.

Confederate Gunboat, Bayou Teche, 1863

FRANK H. SCHELL *c. 1886; ink drawing.*

American Heritage Century Collection, New York.

Union forces shielded by semitropical foliage attack the Confederate steamer *Cotton* on Bayou Teche, Louisiana, to clear the way for a Federal drive up the Mississippi. Schell covered the Mississippi campaigns for *Leslie's*, and produced many evocative drawings.

Pvt. Alfred E. Mathews served with the 31st Ohio and made sketches of camp life and battle scenes in the Western theater. Many were lithographed and distributed by a Cincinnati firm; they are considered the most important and accurate of all the wartime lithographs. Another Ohio artist, James McLaughlin, later a distinguished Cincinnati architect, served with the Benton Cadets and submitted his sketches to *Leslie's* for publication.

Little is known about John T. Omenhausser, a Confederate prisoner and amateur painter. While incarcerated at the Federal detention camp at Point Lookout, Maryland, he made forty-six primitive watercolors depicting the difficult yet animated lives of the prisoners.

Alexander Meinung, a musician with the 26th North Carolina Regiment Band, drew several field sketches of the army on the move and in camp. One of his drawings shows a night camp in North Carolina with men silhouetted against a brightly burning campfire. This is among the relatively few night scenes of the Civil War.

George W. Reed was a somewhat obscure artist whose hundreds of Civil War drawings have been preserved in the Library of Congress. During the war he served in the 9th Massachusetts Battery as a bugler and later as assistant engineer in the headquarters of the 5th Army Corps. In the years to follow, he worked his sketches into line illustrations for a fascinating book on every aspect of Union soldiers' lives, entitled *Hardtack and Coffee*.[11]

Frank H. Schell and Thomas Hogan collaborated in producing large numbers of drawings and lithographs of the war for *Leslie's* and for their own firm. Schell and Hogan sometimes worked in pen and ink, but their most distinctive pictures are a series of large watercolors of Mississippi River naval actions.

Naval subjects were a major focus of Xanthus Smith, a Philadelphia painter who had once studied medicine. He enlisted in the Union navy and saw extensive war service. J. O. Davidson, an illustrator for various publications, was best known for his maritime and naval scenes. Charles Ellery Stedman, a Harvard-trained physician and distant cousin of Winslow Homer, signed on as a naval surgeon and, in between medical procedures, prepared a remarkable record of naval engagements and the lives of sailors. Many other artists, including the French painter Edouard Manet, who pictured a clash between American ships off Cherbourg, France, were fascinated by naval action, and a large number of pictures depict both wooden ships and numerous iron-clad vessels engaged in combat during the war.

Publication

The lively pictures drawn and painted from life by Civil War artists were not published in their original forms during the nineteenth century. No sketch or painting, no matter how excellent, could be printed as such—the technologies of the day did not allow it. Instead, all images sent from the battlefront or from artists' studios had to be laboriously copied by engravers carving onto wooden blocks, from which plates could be made for printing. Alternatively, they could be copied by lithographers onto specially prepared stones that would yield prints.[12] The process was not speedy—from sketch pad to printed page frequently took from three to four weeks.

What the public saw, then, were engravers' versions of artists' work. Many of these copies were far more mechanical and stilted-looking than the spontaneous originals, and some were also distorted and inaccurate. Unfortunately, artists had little or no control over this process and could only take satisfaction in their modest paychecks and in the fact that the public craved to see these images no matter what their imperfections might be.

An artist's drawing, rushed in from the field, was traced onto the smoothly-prepared surface of a block of hard boxwood, turned on end so that the lines could be carved into the end grain like lines engraved on a metal plate. To speed up the process, an illustration-size wooden block was actually composed of a number of small rectangular sections held together by sunken bolts and nuts. After the tracing of the guide drawing, a wood engraver, using fine engraving tools, cut in

Indiana Zouaves at Fort Donelson, 1863

HENRI LOVIE *1863; engraving.*

Art Brown Collection.

With his keen eye for posture and movement, Lovie shows a Federal force advancing with wariness and determination toward the enemy.

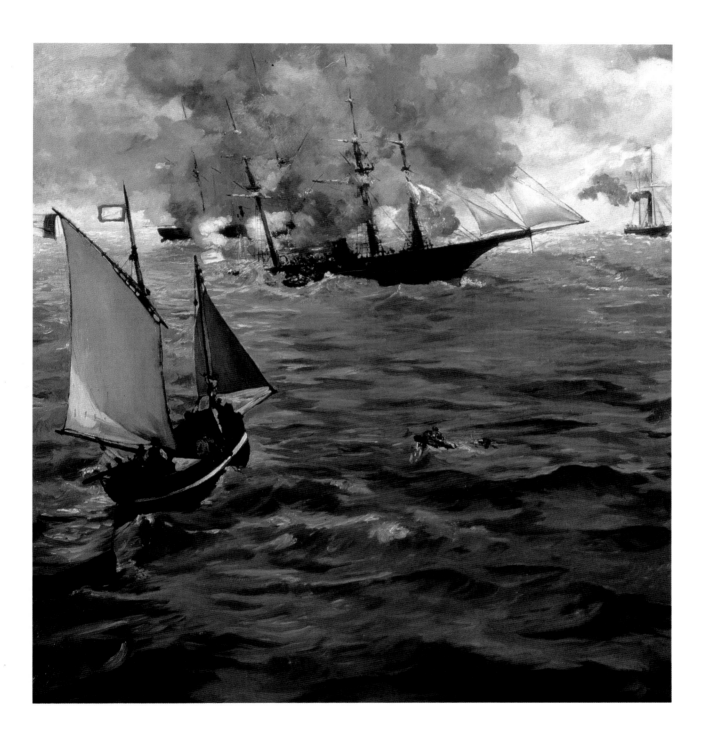

Alabama and *Kearsarge*

EDOUARD MANET *c. 1864; oil on canvas. Philadelphia Museum of Art, Philadelphia, Pennsylvania.*
The raids of the Liverpool-built Confederate ship *Alabama* ended in the English
channel, where the Union ironclad sloop *Kearsarge* caught up with her. The most
successful of all Confederate commerce raiders, the *Alabama* in three years had
seized and sunk sixty-five Union merchant vessels. The great French painter Manet
depicted the furious hour-long battle in June of 1864 off the coast near Cherbourg.

all the lines which crossed from one section to another. The nuts and bolts were then loosened, and the sections taken apart and distributed among several engravers, all of whom could then work on the illustration at the same time.

Engravers were often highly specialized—some did human figures, others trees and foliage, and still others architectural details. Fine technicians, the engravers set to work cutting away the surface of the wood, leaving only the lines of the drawing in relief.

The parts of the block were tightly reassembled and locked up in a form with hand-set type, from which a wax-mold electrotype plate was made. The electrotype was printed as a flat-beveled plate or cast as a curved plate, depending upon which type of printing press was being used. Some five thousand sheets per hour could be printed and rushed to the waiting readers. A normal press run for *Harper's Weekly* was about 125,000 copies, which could be produced in two days.

Pictures hand-copied onto specially treated stone slabs for making lithographs often retained more of their original qualities than did engravings. Tonal gradations were more subtle in lithographs, but the rate of printing was a mere three hundred copies per day, and after a certain number of prints, the grease-crayon images on the stones faded, and prints were poor. The rate of production for printing from copper plates was even slower.

Knowing of this process, field artists suffering from lack of time sometimes submitted incomplete drawings, with sections marked for the engravers: "fill in trees here," "add clouds here,"

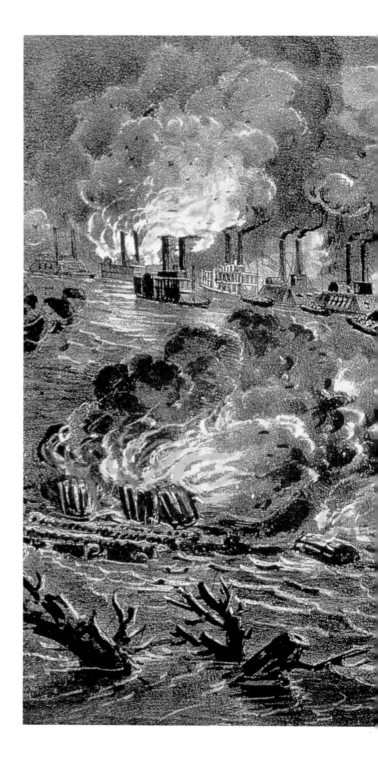

Ironclad Attack on Vicksburg

CURRIER & IVES *1863; chromolithograph.*

U.S. Naval Academy Museum, Annapolis, Maryland.

A frightening Union fleet of ironclad gunboats with transports and barges lashed to their sides run Vicksburg's guns, firing from 200-foot bluffs above the Mississippi River. The ships' invasion paved the way for General Grant's eventual victory at the strategically-located port.

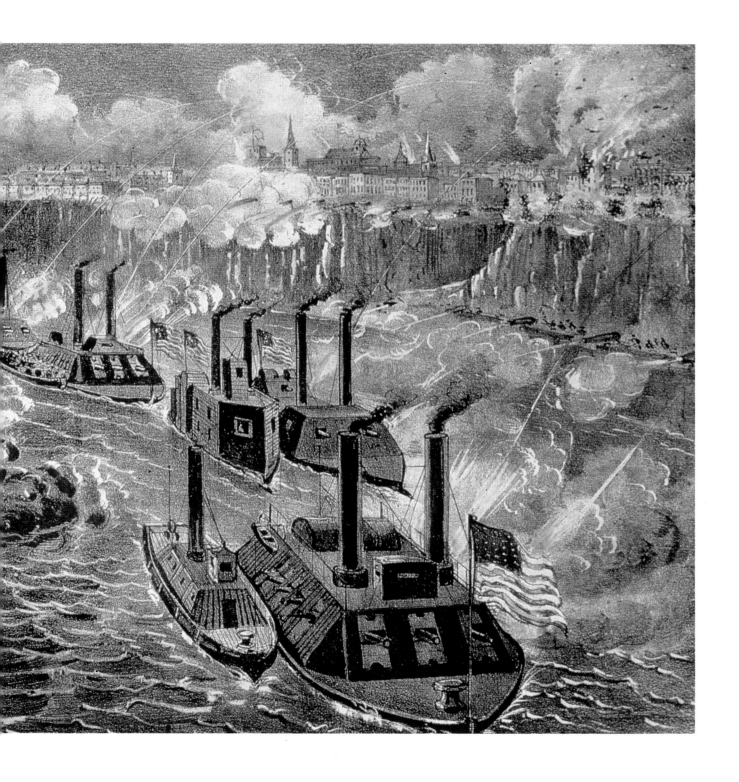

and so on. Some engravers not only followed such instructions but took it upon themselves to radically alter art work, so that the resulting engravings were sometimes very different from the drawings on which they were supposedly based. Frequently, artists' names were omitted.

Sadly, original drawings were sometimes held in such little regard by the publishers that many were tweaked, folded, bent, soiled, and sometimes even tossed away after the engravings had been made. Watercolors were preserved with

more care, and oil paintings tended to be properly hung and preserved whenever possible.

Currier & Ives Lithographs

The Civil War created a burgeoning demand among the American population for already-popular Currier & Ives images. The firm of Currier & Ives had begun its operations in 1835 and became a spectacular success, supplying reasonably priced images of familiar and newsworthy scenes

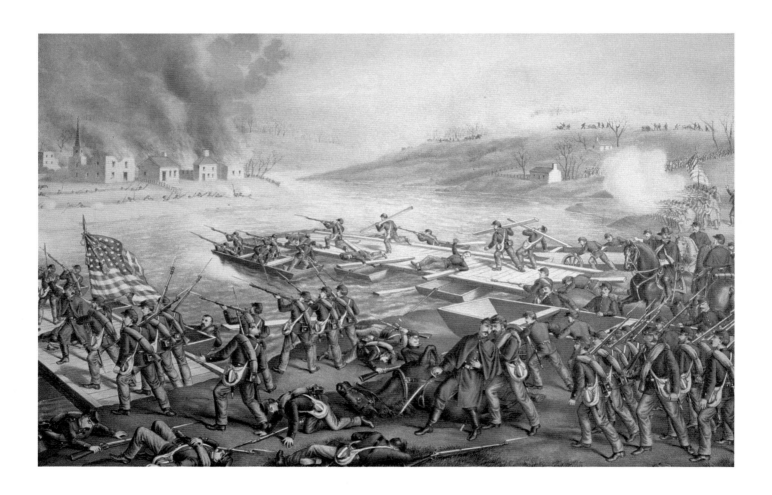

The Battle of Fredericksburg, 1862

CURRIER & IVES n.d.; chromolithograph. Art Brown Collection.

In freezing weather Union troops move across the Rappahannock River in their attempt to take the town of Fredericksburg, Virginia. The casualties of that day—December 13, 1862—were 12,600 for the Federals and 5,600 for the Confederates.

for as little as 25 cents (equal to about $5.00 today). Lithographic prints were hastily produced in great numbers in the firm's New York City shop, hand-colored with stencils in an assembly-line system, and sold on street corners and in general stores across the nation. This formula was repeated again and again for each major engagement of the war. Staff artists like Frances Palmer supplied most images, but other well-known artists such as Eastman Johnson, Arthur Fitzwilliam Tait, and George Durrie sold paintings to Currier & Ives,

who then had them copied onto stone. Accuracy was sometimes a casualty of speed.[13]

The colors dabbed onto the lithographs were often lurid, with bright reds, yellows, blues, and greens enlivening what would have otherwise been simple black-and-white images. Surprisingly, the defects of the prints sometimes enhanced their power. In some Civil War representations, the brilliant scarlet of splotches of battlefield blood made the subjects of the pictures seem to viewers all too real.

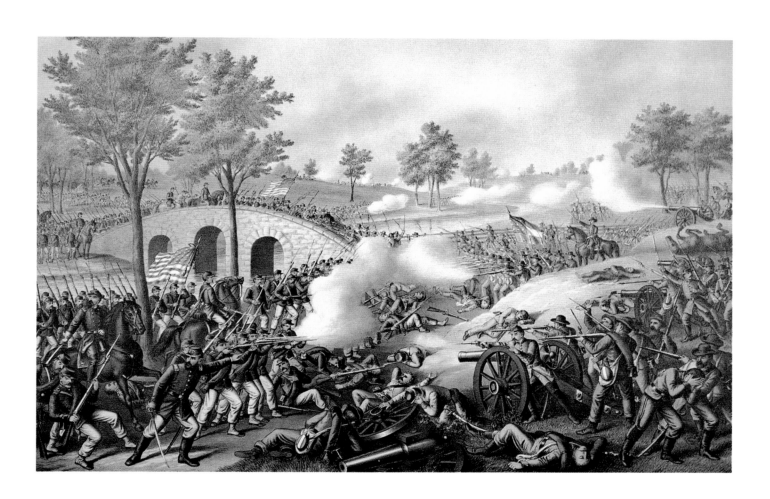

The Battle of Antietam, 1862

CURRIER & IVES *n.d.; chromolithograph. Art Brown Collection.*
Union troops surge over the stone bridge across
Antietam Creek near Sharpsburg, Maryland.
After bitter fighting on both sides, victory was finally
achieved by Federal forces on September 17, 1862—
the bloodiest single day of the war.

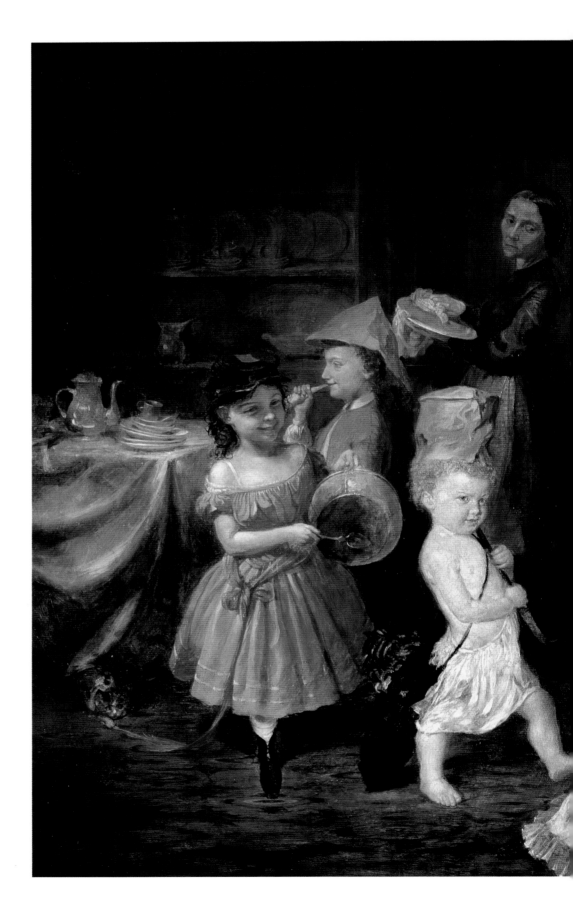

The War Spirit at Home—Celebrating the Victory at Vicksburg

LILY MARTIN SPENCER *1866; oil on canvas. Newark Museum, New Jersey.*

Children celebrate a war victory they cannot comprehend while their mother, cradling a cherubic infant, reads *The New York Times* report of the Union triumph at Vicksburg. In her composition, feminist artist Spencer imaginatively combined domestic and military themes.

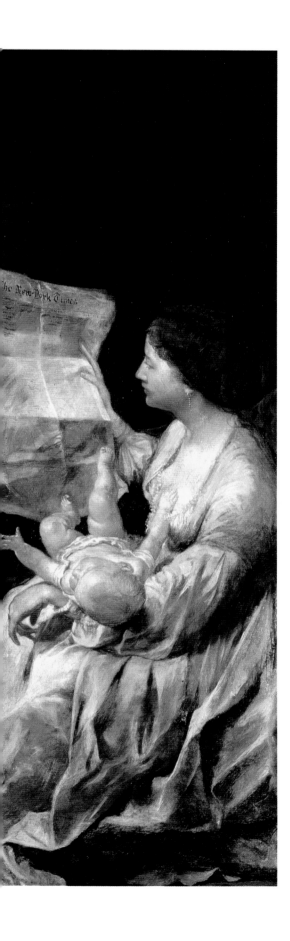

Women in the War

Many women of the Civil War period were accomplished in painting, sketching, and a variety of handicrafts and fabric arts. Lily Martin Spencer was a well-known feminist artist who specialized in painting children, including a sentimental portrayal of her offspring celebrating the Union victory at Vicksburg. Another painter, Anna Mays, depicted in a more primitive style women volunteers working in a field hospital tent.[14]

Among intrepid field artists, however, women appear to be unrepresented. There were dozens of cases of women who secretly fought as men during the war—disguised as males until revealed as women during the indignities of battle or medical examinations. A few women openly fought as women. For example, Kady Brownell served bravely beside her husband in the Rhode Island infantry.[15] Several women acted as spies. However, there is no record of a woman among the ranks of artists on the battlefield. Further, women artists were disinclined to focus on military subjects, preferring scenes of home life.

War was considered a masculine enterprise, with women and children ideally shielded from its cruelties—especially white women. Their bodies trammeled with corsets and drapery, middle-class women especially seemed to need the protection of men. Women were expected to tend to the home and remain pure, sensitive, and delicate. These genteel qualities appear in virtually all artistic images of women of the period, save a few pictures of working-class white and black women. Some artists portrayed women engaged in the highly respectable activities of sewing small items and cooking food for men at the front or organizing fund-raisers for servicemen's hospitals. Artists virtually ignored the thousands of women working at more essential tasks on farms and in factories producing food and weapons for the armies.[16]

A woman's ideal role was considered that of emotional and moral support for her valorous man. Women were encouraged, however, to help with one major aspect of the war effort—caring for the wounded. Women nurses staffed convalescent hospitals, and female volunteers comforted the injured. Clara Barton, known as the Angel of the Battlefield, masterminded the transportation of medical supplies for the army and later founded the American Red Cross. Southerner Phoebe Pember directed the care of over ten thousand injured soldiers in Richmond. Few male combat artists depicted the activities of these energetic women, but Homer, Nast, and others composed a few sentimental pictures of women writing letters for the wounded.

Portraying African Americans

The dispute over the morality and legality of slavery was without question a key issue at the heart of the Civil War. This contentious issue aroused great fascination and emotion, yet surprisingly few artists of the day chose to focus on American blacks or slavery in their works. Few of those who did so emphasized the negative aspects of enslavement. Instead, artists tended to depict blacks in relatively neutral terms.[17]

A key example of a nonjudgmental treatment of slavery is an 1859 painting by the eminent artist Eastman Johnson. *Old Kentucky Home*, or *Life in the South*, as it is also known, seems to show a sweet scene of contented blacks, courting and swaying to the music of a strumming banjo player. Widely praised for its masterful execution and pictorial accuracy, the picture lent no support to abolitionist attacks on slavery. Actually, the painting does not depict Kentucky, but rather portrays the scene behind Johnson's father's house in Washington. Some observers saw in the decaying porch overhanging the figures a suggestion of the impending collapse of the slavery system.

A few years later, Eastman Johnson's vision of slavery's evils had sharpened. In 1862 he personally witnessed a slave family fleeing to freedom in Virginia and recreated the passion of that terrifying escape in a dramatic painting he entitled *A Ride for Liberty—the Fugitive Slaves*. Other artists, too, would record the dangerous travels of black refugees escaping the South.

Many images portray blacks as supporting characters for whites. Some paintings focused on

Old Kentucky Home

EASTMAN JOHNSON *1859; oil on canvas. The New York Historical Society, New York.*

Soft banjo music accompanies contented courting and delighted dancing in this idealized image of Southern slave quarters. In pre–Civil War America, Johnson's pleasant, highly acclaimed vision stirred no abolitionist passions.

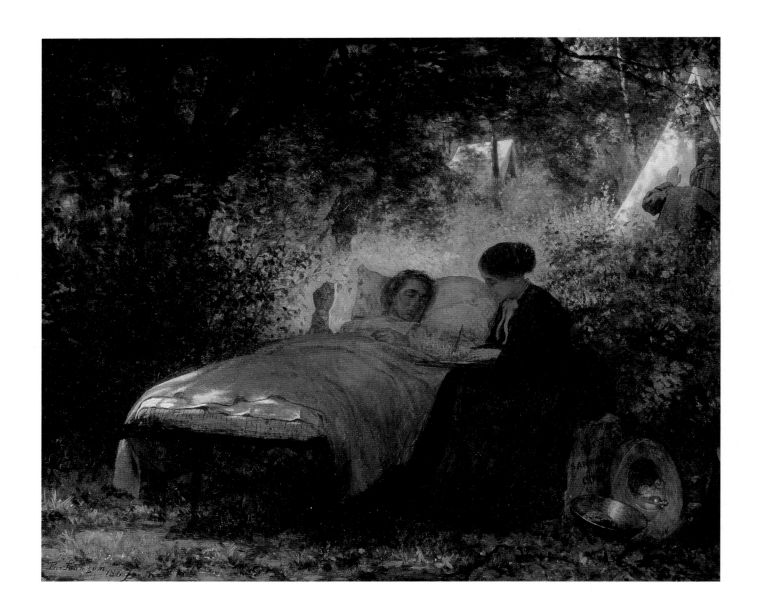

The Field Hospital, or The Letter Home

EASTMAN JOHNSON *1867; oil on board. The Museum of Fine Arts, Boston.*
Pretty patches of light filter through whispering leaves, as a
volunteer from the U.S. Sanitary Commission writes a letter
for an invalid soldier. The idealized serenity of the scene dif-
fers sharply from the miseries of Civil War hospitals. Only the
red stripe on the blanket suggests the bloody violence of war.

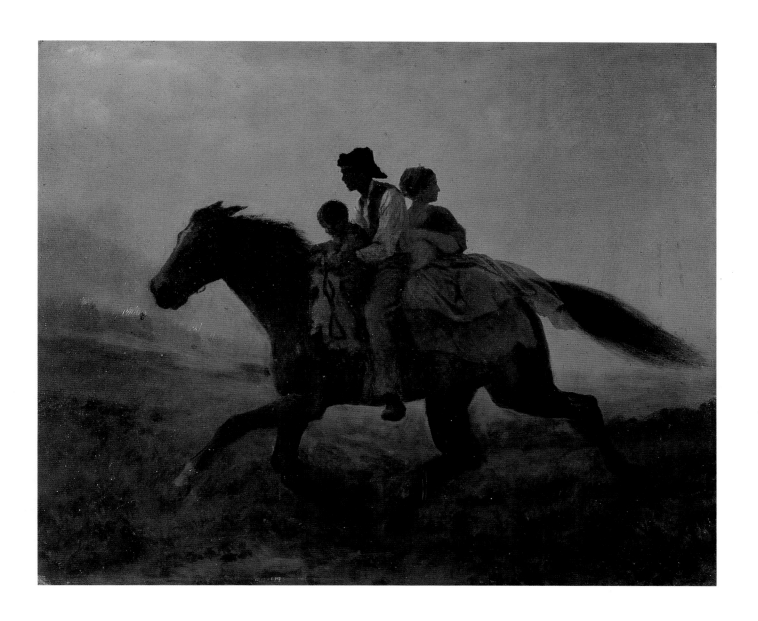

A Ride for Liberty—The Fugitive Slaves

EASTMAN JOHNSON *c. 1862–63; oil on board. The Brooklyn Museum, New York.*

A desperate slave family clings together on horseback in a thrilling
twilight escape from bondage, riding toward Union forces near
Manassas, Virginia. Johnson witnessed such an escape, and it
inspired him to turn from painting prosaic portrayals of slave
life to images of courageous African Americans seeking better lives.

The Carnival

WINSLOW HOMER *1877; oil on canvas.*
The Metropolitan Museum of Art, New York.
In Homer's sympathetic depiction, graceful black women adjust a man's costume for the year-end festival of Jonkonnu in Virginia. The colorful strips on the costume suggest African ceremonial dress, a cultural richness amid the economic poverty faced by newly freed slaves. Two children tenderly clutch American flags.

white-bearded John Brown being led to his execution, stopping for a moment to lovingly caress a black child held by a supplicating mother. Some wartime sketches and paintings included blacks in their roles as support staff for the troops, performing various tasks in military camps. Others show lighter moments, with blacks singing and dancing to amuse white military men. Most poignant are unself-conscious Confederate images of slaves tending to their soldier masters fighting for the right to keep them enslaved.

As the war progressed, and black troops began to fight in combat, painters rendered inspirational images of blue-uniformed black soldiers in military drill scenes, fighting hand to hand with white soldiers in gray, and marching victorious into Charleston. The artist of the period best known for his sympathetic and dynamic representations of African Americans was Winslow Homer, one of the great painters of his time. In some of his most stirring images, black protagonists take center stage.

The Letter for Home

WINSLOW HOMER *1863; lithograph. Philadelphia Museum of Art, Philadelphia, Pennsylvania.* The gentle presence of a woman soothes a wounded soldier as he dictates a letter home to his loved ones. Hundreds of women served as nurses and aides in field hospitals, caring for the sick and injured. A few women even served in combat.

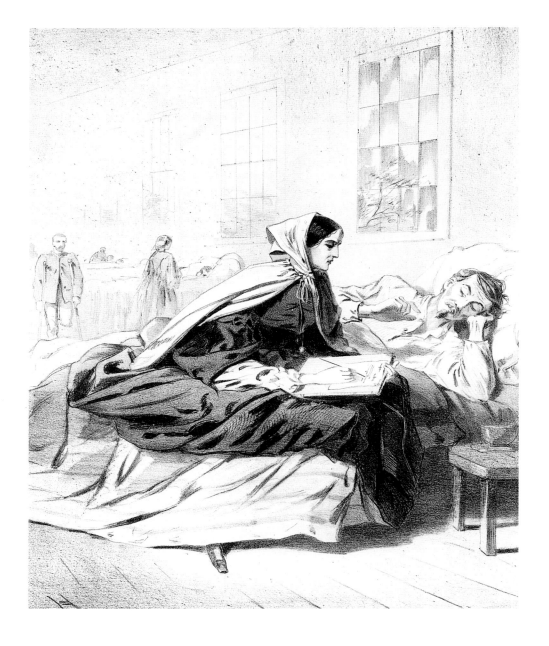

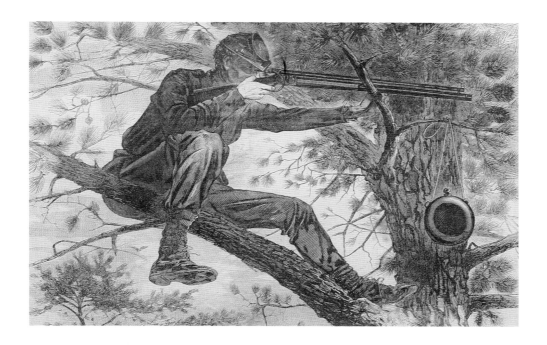

**The Army
of the Potomac—
A Sharp-Shooter
on Picket Duty**

WINSLOW HOMER *1862;*

wood engraving. The New

York Public Library.

A Union soldier seated
in a tree takes aim at an
enemy visible through
the branches. Winslow
Homer employs a striking
vantage point and strong
angles to portray the
stress of the soldier's
intense assignment during
the Peninsular Campaign.
The image earned early
fame for the young artist.

Winslow Homer

Born into a close-knit Boston family on February 24, 1836, young Winslow Homer[18] was the second of three brothers. His father was a hardware importer, but his mother painted accomplished watercolors, and the boy followed his mother's artistic bent. Homer's father lost his savings in a poor investment, and at age nineteen, instead of attending nearby Harvard, Winslow found himself answering a newspaper advertisement: "Boy wanted: apply to Bufford, lithographer; must have taste for drawing; no other wanted."

Thus was one of America's greatest artistic careers launched. Homer hunched over the drawing boards for Bufford for two years, producing uninspired illustrations for sheet music and a composite image of forty-two state senators' portraits. Once released from his apprenticeship, he vowed never to be bound to an employer again. He honed his skills in drawing for woodblock reproduction, essential to his work as freelance artist for popular publications. Forever after, his artistic style would reflect his early training in strong simple lines and silhouettes, characteristic of printed illustrations. He was also influenced by Japanese woodcuts, recently introduced into the United States, and by photographic images as well.

Ballou's Pictorial and *Harper's Weekly* published many of the talented Homer's charming scenes of folksy American life, and the dapper, well-tailored artist moved to New York to become part of that city's active artistic community.

When war rolled over the nation, engulfing all in its wake, Homer became a freelance artist at the front in 1861. He marched with General McClellan's troops, and in 1862 traveled with the Army of the Potomac for part of the Peninsular Campaign. His dynamic scenes of battles and camp life were regularly published in *Harper's*, and he filled his notebooks with sketches for pictures to be finished back in his studio. The Civil War made Homer famous; in particular, *A Sharpshooter on Picket Duty* gained him much early notice.

Mature Artist

Suddenly, at age twenty-five, Homer decided to learn how to paint. He signed up for five quick nightschool lessons with an obscure French artist, and then he began to paint in oils. He quickly produced a remarkable body of work, focusing almost exclusively on the Civil War. Within four short years, his dazzling paintings would earn him the honor of full membership in the National Academy of Design.

He worked color and shape on his canvases to convey his sympathies for the combatants and the dreadful deeds they were forced to commit and endure. No glorious victories were portrayed; rather emotions of desperation, sorrow, pleasure, and emotional pain were allowed to shine through the layers of his paint. In Homer's work, sentimentality was muted, realism powerful.

Although Homer did follow troops in the field, he did so less frequently and for shorter periods than did many, such as the adventurous Theodore Davis and the Waud brothers. He far preferred finishing his works in his studio to dodging bullets.

As the Civil War neared its end, Homer began work on a canvas that would earn him tremendous acclaim. In *Prisoners from the Front*, a dapper yet troubled Union officer (modeled after Major General Francis Barlow, to whose staff Homer was attached) receives three Confederate prisoners—a defiantly dignified young soldier, a worn-out elderly warrior, and a slouching youth apparently bewildered by all that has happened. Behind them stretches a landscape spattered with the

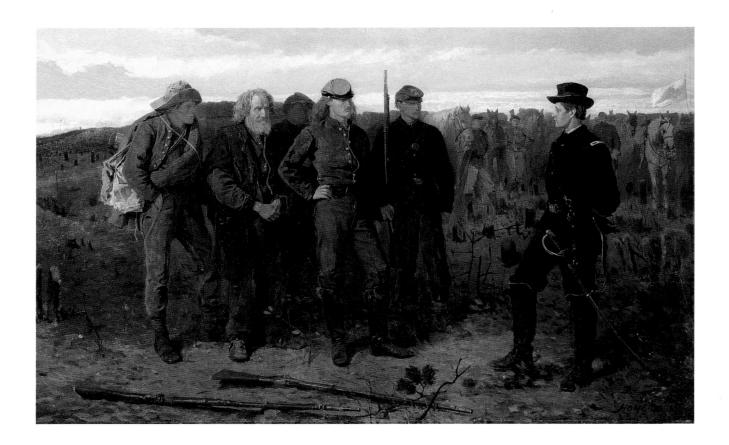

Prisoners from the Front

WINSLOW HOMER *1866; oil on canvas. The Metropolitan Museum of Art, New York.*
Amidst a desolate landscape, three Confederate prisoners are delivered to a Union officer, an encounter that virtually summarizes the Civil War. The victorious general is dashing yet troubled in the face of the proud prisoners, whose surrendered weapons lie at their feet. The picture suggests the inevitable yet difficult postwar reconciliation between the North and the South and is widely regarded as Homer's most important war painting.

stumps of trees destroyed by the war. Here victor and vanquished meet and begin to comprehend that, despite their differences, they will soon have to work together in the reunited nation.

Homer marked the end of the war with a seemingly simple, yet emotionally and ideologically complicated, composition, *Veteran in a New Field*, painted in 1865. Under a hot sunny sky, a former soldier returns to the serene beauty of his farm, peacefully harvesting his abundant wheat crop with a scythe—an implement so recently wielded by the Grim Reaper on the battlefields of the war.

Homer was attracted to African Americans as subjects for his paintings, and his images convey a rare sympathy for blacks. Whether picking cotton, earnestly studying, or contending with the forces of the sea, individual black men and women are the central figures in several of Homer's finest paintings. *The Carnival*, from 1877, is considered a masterpiece of color, character, and social history.

After the war, Homer traveled to Paris, where his *Prisoners from the Front* and another Civil War painting were exhibited in an important world's

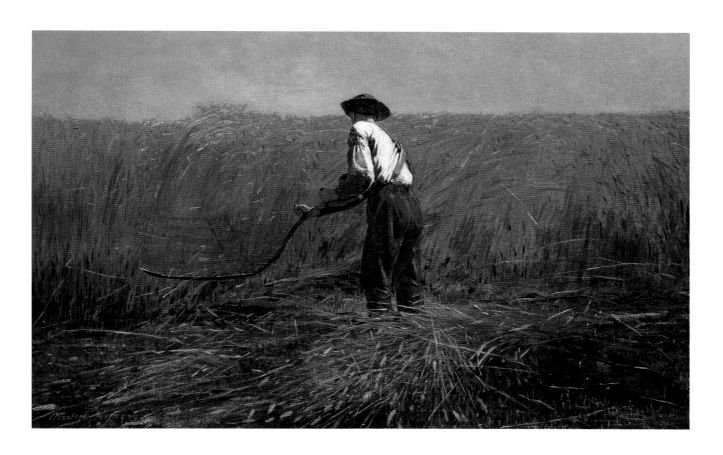

Veteran in a New Field

WINSLOW HOMER *1865; oil on canvas.*

The Metropolitan Museum of Art, New York.

His worn army jacket cast aside in the heat, a war veteran harvests golden wheat with his scythe, rather than the death of the battlefield which he has so recently left. Homer's composition emphasizes the stalwart farmer's return to his beloved land, blessed once more with peace and bounty.

fair. Ultimately, Homer grew tired of the endless celebrity of his *Prisoners* painting and of urban life, and he moved to coastal Maine. There, and in Florida and the Caribbean, where he sometimes visited, the drama of the individual facing the forces of water, wind, and landscape inspired a multitude of the brilliant images, many in watercolor, for which he remains celebrated throughout the world.

Historic Endings

The Civil War and its epoch ended with two grand finales: the surrender of General Robert E. Lee to General Ulysses S. Grant at Appomattox Court House, Virginia, and the assassination of President Abraham Lincoln in Washington, D.C. Although visual artists—painters, sketchers, and photographers—had put themselves in harm's way to witness and record virtually every other

aspect of the war, these two pivotal final events occurred with so little warning that no artists were on hand to see them.

As a result, all visual representations of these historic endings—both from April of 1865—were created after the fact by artists eager to commemorate the events for posterity. Some portrayals are accurate to a great degree, while others are slightly inaccurate and a few surprisingly fanciful.

On the whole, however, in depicting the conflict that took a young nation from an era of relative innocence and optimism into an epoch of challenge and hard reality, artists of pencil and brush admirably performed their invaluable task of bringing realistic images of war and its attendant suffering as well as rare moments of pleasure during duress to the people of the United States of America.

Wounded Soldier Being Given a Drink From a Canteen

WINSLOW HOMER *1864; charcoal and chalk on green paper. Cooper-Hewitt, National Design Museum, New York.*

Gently supporting his comrade as he offers him a drink of cool water, a soldier shows the strength of friendship and mutual support that developed among men at arms.

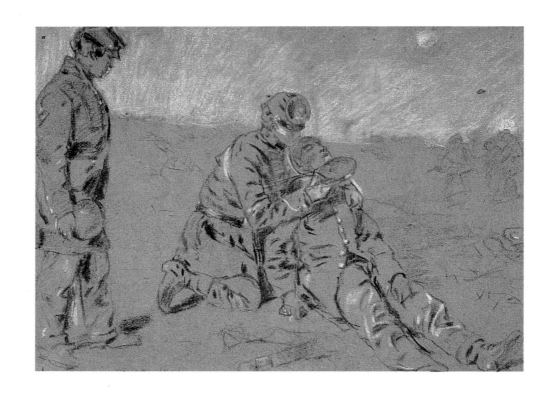

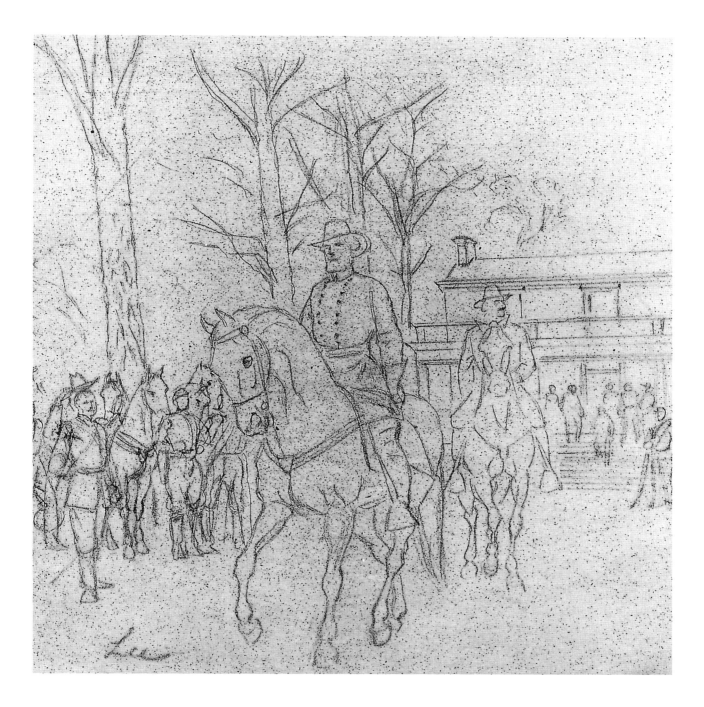

General Lee Leaving the McLean House after the Surrender

ALFRED WAUD *1865; pen sketch. The Library of Congress, Washington, D.C.*

In the moments after his surrender, General Robert E. Lee bravely rides out to tell his loyal forces
of the final outcome of the war. Alfred Waud was the only visual artist in the vicinity at the historic
moment. He developed this completed pen sketch from impromptu drawings he had made on the spot.

News from the War: Wounded

WINSLOW HOMER *1862; wood engraving.*

The New York Public Library.

Tragic news has reached a woman, bent in sorrow.
The sad tidings of her husband's wounds have reached
her in a letter long in coming. The artist's treatment
is simple but effective, portraying her deep grief.

Off to the Front

UNKNOWN ARTIST *c. 1861; oil painting. West Point Museum,*

U.S. Military Academy.

The horrors of war at the front were matched only by the sorrow of those left
behind at home. Wives and mothers sending husbands and sons off to war spent
miserable weeks waiting for news of their loved ones.

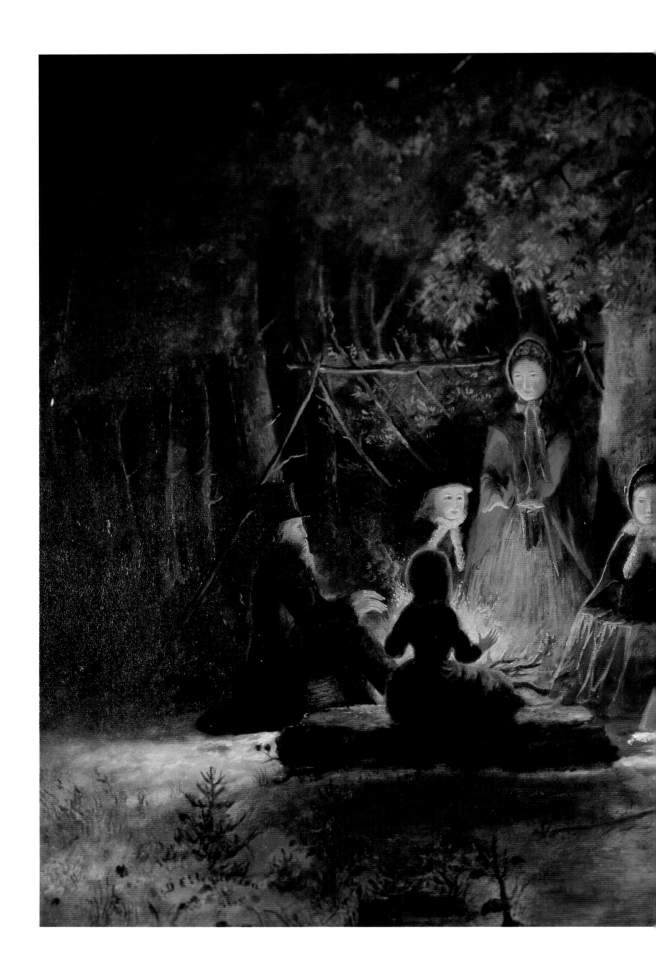

Refugees from Fredericksburg

D. E. HENDERSON *1862; oil on canvas.*
Gettysburg National Military Park
Museum, Pennsylvania.
A refugee family from
Fredericksburg, Virginia,
huddles beside a campfire
in the woods as, sadly, they
send a young family member
back to fight with General
Lee's army. Attacking Federals
had shamelessly looted
Fredericksburg, driving
people from their homes
in the cold of December.

Watching the Maritime Duel

UNKNOWN ARTIST *June, 1864; oil on canvas.*

U.S. Naval Academy Museum, Annapolis, Maryland.

Citizens of Cherbourg, France, gather on seaside
bluffs to witness the battle between the American
ships *Alabama* and *Kearsarge*. Through their spy-
glasses, some 15,000 spectators watched the
Kearsarge sink the beautiful Confederate raiding ship.

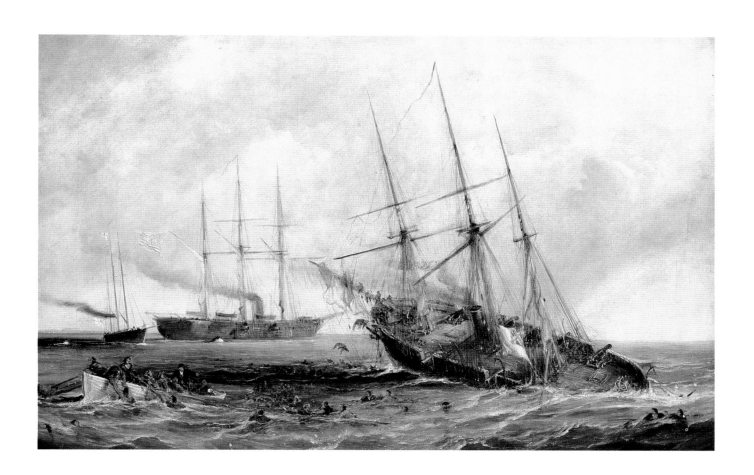

The Sinking of the *Alabama*

UNKNOWN ARTIST *1864; oil on canvas. Chicago Historical Society, Illinois.*

As the magnificent masted *Alabama* slips beneath
the waves, Confederate sailors struggle toward a
lifeboat dispatched by the British yacht *Deerhound*,
at left. The Union seized its chance to attack the
Confederate ship when it was anchored off the
French coast. Union lifeboats also picked up survivors.

**Defiance: Inviting
a Shot Before
Petersburg, Virginia**

WINSLOW HOMER *1864;*

oil on panel. The Detroit Institute

of Arts, Detroit, Michigan.

A soldier, starkly silhouetted
against a broad sweep of
sky, courageously invites
his own doom. Not readily
identifiable as Union or
Confederate, he symbolizes
Everyman amid the collective
madness of the conflict.

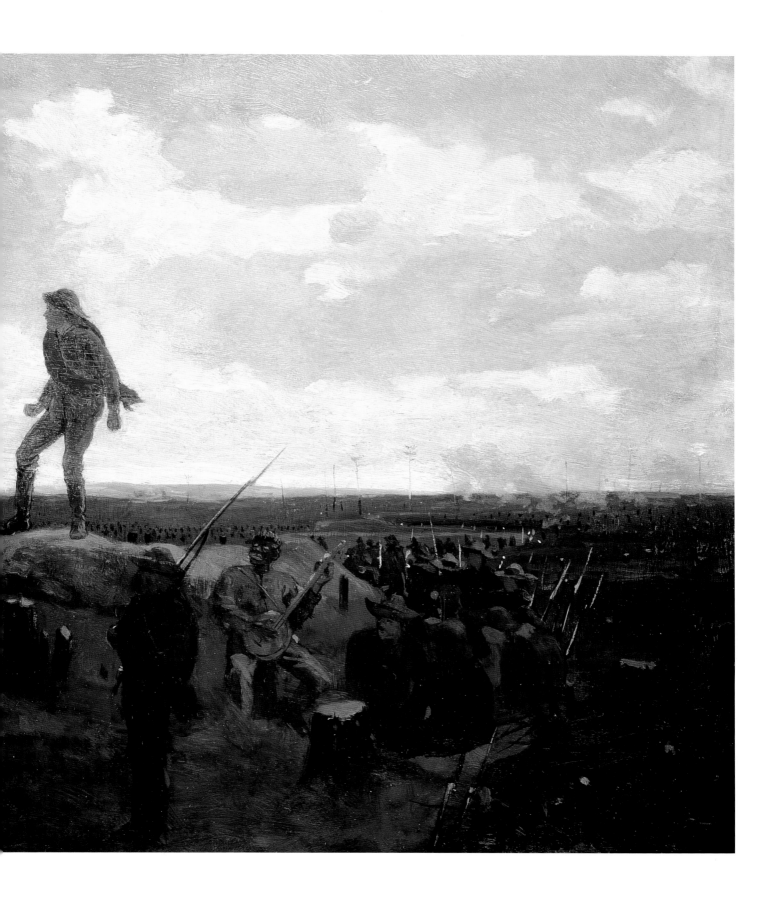

Photographing the Civil War

At the time of the Civil War, the world was welcoming a new kind of artist, one who created pictures not with pencil, crayon, or brush, but with ground glass, wooden boxes, sunlight, and chemicals. For those experimenting with this challenging new medium, the Civil War would provide a multiplicity of dramatic images.[19]

A New Art

The new and powerful black-and-white images were to form the basis for a vast array of pictures published in numerous newspapers, magazines, pamphlets, and other publications throughout the war. With the advent of photography, graphic illustration became an integral part of journalism. Through photographic images, mass communication underwent a revolutionary transformation.

In the 1860s, even as it was impossible for publishers to publish plates made directly from drawings or paintings, it was also impossible to do so directly from photographs. Instead, photographs, like drawings from the battlefront, were copied by engravers. Photographs were also used as models for lithographs—reproductions yielded from specially treated stone slabs—produced and sold to the public, and for paintings as well.

Confederate Lines Near Atlanta, 1864

UNKNOWN PHOTOGRAPHER *1864; photograph.*

The Library of Congress, Washington, D.C.

Confederate forces prepare a strong defense of Atlanta by guarding its vital rail links to other Southern cities. These formidable defenses slowed but could not stop Sherman's advancing army. The city fell on September 2, 1864.

While some early photographers considered such inaccurate and sometimes stilted reproduction of their work a distortion of their art, not all agreed with this view. Mathew Brady, the Civil War's most famous photographer, who himself began his career as a painter, wrote in 1855, "I have endeavored to render it [photography] as far as possible an auxiliary to the artist. . . . I have esteemed this of paramount importance."[20] Some of the masterful early photographic portraits by Brady and others closely resemble painted portraits in pose and lighting. Later photographs would exhibit more artistic creativity in the new medium.

Actual photographic prints were made in abundance at photo studios and were sold individually throughout the country. Special limited editions of photographic collections were also assembled, with photographic prints glued to pages bound in costly bindings. Stereoscopic photo prints, viewed through simple hand-held devices, became extremely popular, and small personal portraits, known as *cartes de visite,* were bought in the millions.

It was not until the development of modern photoengraving methods and materials that photographs could be used directly for publication, and screens of various degrees of fineness to produce half-tones did not come into general use until after the 1880s. Thus, many of the Civil War's greatest photographs were not widely seen in their original forms until long after the war itself.

Impact on the Visual Arts

As photography gained influence, it began to re-shape painting, becoming a major influence in the development of the concept of "realism" in later nineteenth-century painting[21] and playing a prominent role in American visual culture.[22]

Early daguerreotypes, with their natural, frank portrayals of individuals or couples, particularly affected portrait painting, even as photographic styles were influenced by painting. When photography was used, as it would be, to document the horrors of the Civil War, romantic painted representations were challenged by the uncompromising realism of such images. In this and other realms, photographers pioneered the exploration of pictorial themes that would later attract artists working in other media.

Photography contributed significantly to the democratization of art in America. With the invention and expansion of this singular medium, almost everyone gained access to images of themselves and others of their social circle. No longer was portraiture limited to the wealthy or those considered picturesque enough to be painted—in fact, photography virtually wiped out portrait painting. In the wake of the arrival of this new medium, images of the daily lives of the majority of the population became commonplace, affecting all artistic conceptions.

Photographers in the Civil War era, even as they do now, often had backgrounds in drawing and painting, and photography became their means of artistic expression as well as of documentation. In the early decades of photography's expansion, photographers began to outnumber other visual artists in America.

Bull Run

Three months into the Civil War, in July, 1861, a Confederate force was encamped at Manassas Junction, Virginia, just twenty-five miles from the Capitol dome. Politicians and newspapers cried out for action against these rebels proudly strutting along Bull Run, a creek scarcely out of sight of the troubled President's office. Lincoln ordered General Irvin McDowell to attack and drive away the enemy forces, even though the commander wanted more time to organize his green troops. Misled by overconfidence and failure to grasp the reality of Confederate strengths, McDowell led thirty-five thousand men out of Washington.

The enthusiastic military procession was accompanied by a gaggle of spectators in carriages and on horseback, trundling picnic baskets as if on a delightful country outing. Congressmen,

Ulysses S. Grant

MATHEW BRADY *1864; photograph.*

The Library of Congress, Washington, D.C.

Lieutenant General Grant pauses for a moment outside his tent during the siege of Petersburg, Virginia, which lasted nearly ten months in 1864–65.

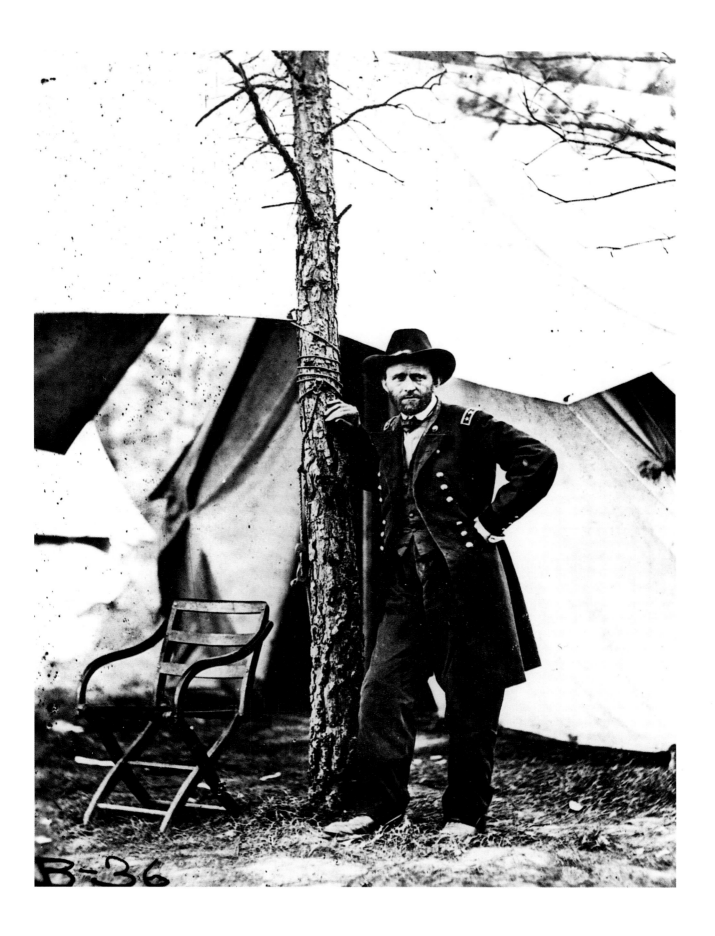

B-36

ladies, and other city dwellers joined the party, eager to see the Confederates routed. Only as the march progressed and was slowed by heat, dust, and exhaustion, did the fun begin to wane. Watching the straggling party approach over the course of a few days, Confederate General Pierre Beauregard had plenty of time to plan his strategies and call for reinforcements, bringing his strength to thirty thousand men.

Unique among the vehicles in this procession was a lumbering horse-drawn wagon, cloaked in black, jammed with a collection of chemicals, glass plates, wooden boxes, cameras, lenses, and other equipment. Riding inside was photographer Mathew B. Brady, self-consciously dressed like a French art student in a broadcloth suit, linen duster, and broad-brimmed straw hat, his red hair

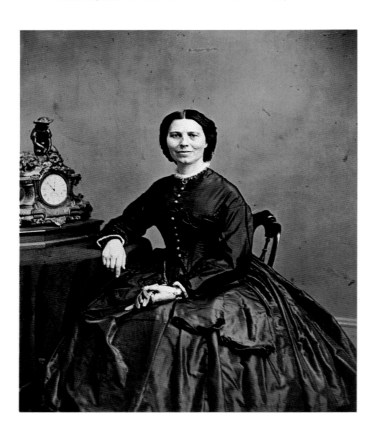

Clara Barton

MATHEW BRADY *1866; photograph. The New York Public Library.*
The "angel of the battlefield," Clara Barton became famous for her heroic work as she attended the wounded and the dying in combat and under fire. After the war Barton founded the American Red Cross.

peeping out. With him were Alfred Waud, combat artist for *Harper's Weekly*, and a newspaper reporter.

Brady recognized the importance of the growing war and vigorously sought to record the conflict. He had prevailed upon President Lincoln to provide him with a personal handwritten note, inscribed "Pass Brady" and impressively signed "A. Lincoln." Unable to secure federal funding for his project, Brady, a renowned society photographer, committed himself, his assistants, and his resources to the risky business of photographing combat and conditions in the field. Later, Brady recalled that he felt he just "had to go. A spirit in my feet said 'go,' and I went." In so doing, he played an essential role in the creation of a magnificent artistic and historic visual archive.

Brady imaginatively assembled his mobile photographic studio and laboratory, outfitting what troops would come to call the "Whatsit?" wagon. Brady did not invent the idea of a portable studio—similar contraptions had been used previously by country artists and even a photographer of the Crimean War, during the previous decade. But Brady popularized the vehicle for American photographers. Keeping up with McDowell's soldiers as best he could, Brady prepared to shoot the action at Bull Run. The topography and the logistics of the battle thwarted attempts at clear views for camera and idle spectators alike, but Brady did photograph various scenes. In the dramatic confrontation, Confederate strategies planned by Beauregard and Thomas "Stonewall" Jackson combined with Union delays and fumbles led to a wild retreat of the Union army. Tossing their guns aside, running crowds of Federal soldiers engulfed the carriages, snatched the horses, and dashed away. In the confusing maelstrom, carts and wagons were overturned, Brady's photo wagon among them.

Brady managed to save some of his fragile glass photographic plates, and for three days he and other stragglers wandered about the countryside. Limping back into Washington, he went straight to his studio to record himself on film—the intrepid photographer still dressed in his rumpled and dirty duster and straw hat.

Brady's Bull Run adventure was highly praised, and his photographic prints sold widely. He brushed the dust from his jacket and correctly assessed that there was fame to be gained by photographing what now promised to be a long war.

Assembling several photographic teams and wagons, he dispatched them to travel with the Armies of the Potomac, Tennessee, Red River, Cumberland, and the Gulf. Brady later claimed to have expended more than $100,000 on the venture, much of which he did not recoup. Although the resulting prints were marked "Brady," it is clear that but a small fraction of the photographs were actually made by Brady himself. In fact, it was his assistants who braved the battles and did most of the work.

Hundreds of other photographers inspired by Brady's success departed for the war zones; more than three hundred recorded the actions of the Army of the Potomac alone. While many photographers were more prolific or more personally adventurous than Brady, he remained the best-known photographer of his day.

Early Photography

It was not until the early 1820s that anyone saw a photograph, a focused, permanent image created by light acting upon a chemically sensitive surface. The camera obscura—a darkened chamber with an aperture admitting light to cast a reverse image on the opposite wall—had been used for centuries by artists and scientists. Such images were but fleeting, disappearing with the setting sun. Working to transform these visions into a permanent form was Joseph-Nicéphore Niepce, an inventor working in an attic in Chalon-sur-Saone, France. In 1826 he placed a highly polished pewter plate inside his camera obscura, focusing on its shiny surface a sharp image of the view outside his window. The plate was coated with an asphalt which became hard when exposed to sunlight. Niepce allowed the image to sear the surface for eight hours, then washed the plate with a mixture of lavender oil and turpentine, thus removing all traces of the asphalt not hardened by the sunlight. What remained on the pewter was what is now the oldest photograph in existence.

Niepce made relatively little of his seminal accomplishment, and he died in 1833. However, he had gone into partnership with Louis Daguerre, who later brought the new process vast fame. In 1839, Daguerre announced to the French Academy of Sciences his version of the method—exposing a silver-coated copper plate to sunlight, creating a sharp image in about thirty minutes. In exchange for revealing his secret, Daguerre

His Excellency Jefferson Davis

JOHN ROY ROBERTSON *1863; oil on canvas. The Museum of the Confederacy, Richmond, Virginia.*

While Robertson was working in the traditional way, Brady, Gardner, and others were applying painterly theories to photographic portraits that both captured likeness and illuminated character. Robertson, a little-known artist, painted this work at the executive mansion in Richmond, pleasing the President of the Confederate States with the flattering image.

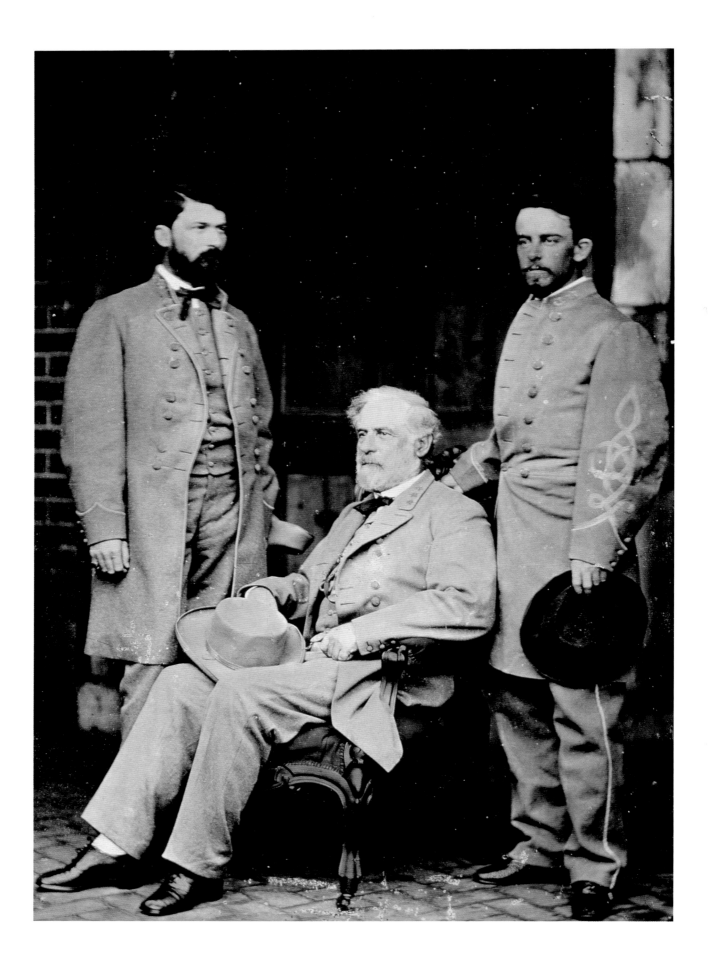

received an annual income from the French government, and news of the daguerreotype swept the world.

Samuel Morse, an American painter best known for inventing the telegraph, was visiting Paris at the time. Fascinated by the process, he wanted to apply it to portraiture, and experimented with exposures back in New York. A mania for the daguerreotype spread across the United States, even as a young country artist named Mathew Brady from Warren County, New York, arrived in bustling New York City to seek his fortune. Soon Brady began working with Morse, and he and many others opened daguerreotype studios catering to New York's burgeoning population.

As in all studios of the period, the actual photography was often done by so-called "operators," who were not credited for their work. Brady, with his painter's eye, taught his operators key setup, lighting, composition, and retouching techniques, chose equipment, organized promotion, and oversaw the entire operation in New York and, eventually, in an additional studio on Pennsylvania Avenue in Washington, D.C.

Through the efforts of those working in his studios—mostly men, but also a few women—and his own amazing acumen in obtaining publicity, Brady drew an immense clientele consisting largely of prominent people. He became renowned as the photographer of presidents, statesmen, visiting royalty, actors, military figures, and business executives—in short, the rich and famous of the time. As did other photographers of the mid-1800s, he added to his image collection by copying existing pictures of celebrities who had never entered his studio. These, like all the other photographs he exhibited and sold, bore the inscription "Brady."

Adding to Brady's fame was the receipt of a major prize for his daguerreotypes at the 1851 Great Exhibition in London's Crystal Palace. In

Robert E. Lee with Two Officers

MATHEW BRADY *1865; photograph. The New York Public Library.*
As a companion to his famous 1865 portrait of Lee, Brady also photographed the great general with two of his officers. Lee is seated with General Custis Lee to his left and Lieutenant Colonel Walter Taylor to his right. The picture was subsequently hand colored.

that same year, British sculptor and inventor Frederick Scott Archer announced the glass-negative collodion process, which would revolutionize photography. Instead of yielding a single delicate image, as did Daguerre's method, the new process allowed the endless production of inexpensive paper prints from a single negative.

Brady learned the process from John Adams Whipple of Boston, who perfected the process in America. Brady and his new assistant, Alexander Gardner, a sensitive and skilled Scotsman who managed Brady's Washington studio, mastered the new techniques and used them in producing many thousands of remarkable images. Especially popular were Brady's life-sized "Imperials," portraits elaborately retouched and embellished with brushwork, and small photographic portrait *cartes de visite*, millions of which were printed by Brady and the rest of the world's photographers. Many photographs were made as twinned images to be viewed through a stereoscopic viewer.

The new "wet-plate" process involved the painstaking use of collodion, a sticky substance composed of nitrated cotton mixed with alcohol and ether, as an agent to make the light-induced image adhere to a plate of clean glass, usually 8 by 10 inches. In darkness, the "excitants" bromide and iodide of potassium were added. As the volatile ether and alcohol evaporated, the resulting smooth, transparent film was sensitized by a silver nitrate bath. This sensitivity was ephemeral, however—as the plate dried, the sensitivity vanished. Thus, the wet plate, carefully shielded from light in a special holder, had to be rushed into the camera, exposed, and rushed back to a darkroom or tent to be developed in a solution of iron sulphate and acetic acid. The image was then "fixed" with potassium cyanide and bathed in distilled water. At any point, contamination from a slight breeze, dust, or even a breath, could ruin the entire operation. The resulting glass negative, carefully handled and stored in a slotted wooden box to prevent breakage, was then used to create photographic prints on sensitized paper.

It was the bulky cameras and other equipment necessary for employing this complex new process that Brady's "Whatsit?" wagons carried into the Civil War conflict zones, and it was on these delicate chemical-smeared glass plates that the drama of the harsh conflict would be recorded for posterity.

Brady and President Lincoln

In February of the election year of 1860, Brady first met and photographed presidential candidate Abraham Lincoln. The one-time railsplitter, an unpretentious lawyer from Springfield, Illinois, arrived in New York to speak eloquently to a crowd at the Cooper Union, philanthropist Peter Cooper's free school of the arts and sciences. Before he spoke, Lincoln, wearing a crushed suit, was conveyed to Brady's studio to have his portrait made. Later, Brady recalled, "When I got him before the camera, I asked him if I might not arrange his collar and with that he began to pull it up. 'I see you want to shorten my neck,' said Lincoln." Indeed, Brady succeeded in making Lincoln look his best, and the resulting flattering photograph appeared during the campaign as a wood engraving in *Harper's Weekly* and on thousands of cards, banners, and buttons. Currier & Ives sold striking lithographs made from the picture.

Lincoln won the election and successfully brought the nation through the most traumatic period it has ever endured. Years later, Lincoln introduced Brady to a fellow visitor at the White House, saying, "Brady and the Cooper Institute made me President." It may indeed be that without that influential image, the course of American history might have been different.

Both Mathew Brady and Alexander Gardner photographed Lincoln many times during the war, both in studio settings and at outdoor occasions. Gardner made thirty-seven portraits of Lincoln—more than any other photographer.[23] Some of the most famous Lincoln portraits—the images on the Lincoln penny and the American five-dollar bill—were made in Brady's studio, either by Brady or his assistant Anthony Berger.

Cameras and Cannons

As the war expanded, hundreds of photographers packed their wagons and headed for the action. They surged into every venue, with and without official passes, getting where they needed to be by dint of persuasion, daring, and sub-terfuge. Prominent among them were Brady's key employees, Alexander Gardner, his brother James Gardner, Timothy O'Sullivan, Guy Foux, David Woodbury, and George N. Barnard. Brady himself was becoming so near-sighted that it was difficult for him to focus a camera, and he was not often in the field. However, when he did appear, he masterfully choreographed group photographs, and, on occasion, placed himself in the composition as his camera's lens was being uncapped by an assistant.

Gardner worked for Brady for the first year of the war and then set out on his own, taking with him many of Brady's assistants, most notably O'Sullivan and Foux. Major points of irritation were Brady's reluctance to leave his city luxuries for the field and his refusal to credit any of the actual photographers with their work. Gardner was much more careful to give credit where it was due—to those tough photographic artists who underwent incredible hardships to complete their work.

Interestingly, another former Brady employee, George S. Cook of Charleston, became an eminent photographer of the Confederacy. Other Confederate photographers included S. R. Seibert and A. B. Lytle, who also served as an effective spy for a time.

The itinerant photographers camped with their fragile equipment beside the soldiers in heat and cold, and stood virtually beside them in the heat of battle. They watched their friends fall to the roars of cannons and cry with pain as their damaged limbs were severed by field surgeons. They covered their nostrils with handkerchiefs to avoid

Abraham Lincoln

ALEXANDER GARDNER *1865; photograph.*
The Library of Congress, Washington, D.C.
President Lincoln gazes wearily into the future in this classic portrait. As president, Lincoln faced challenges more formidable than any that had ever before beset a leader of the United States.

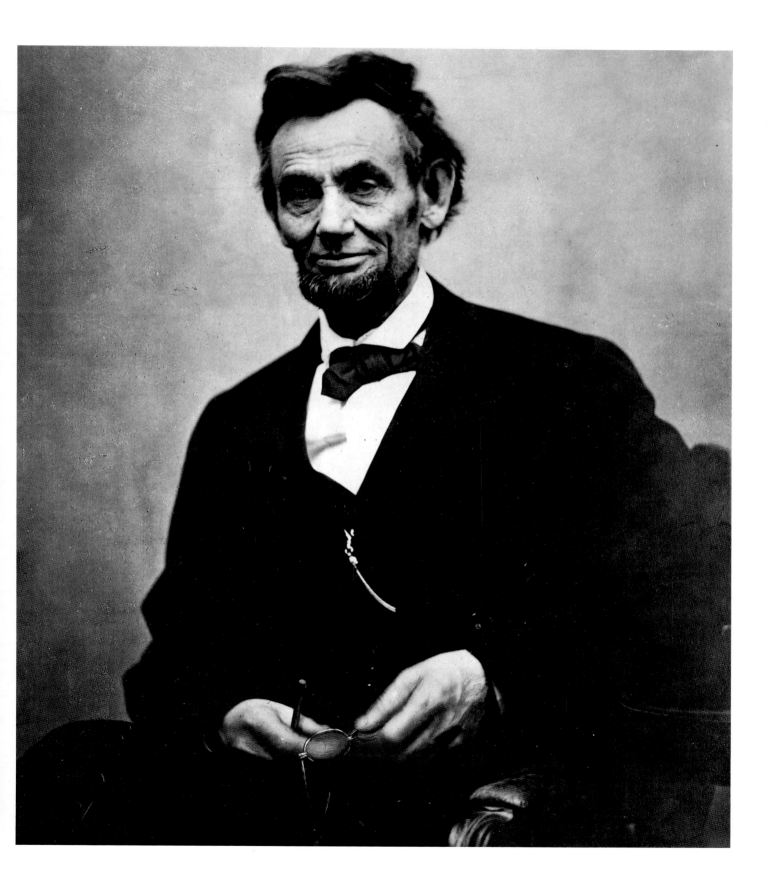

PRESIDENT LINCOLN AT HOME.—[PHOTOGRAPHED BY BRADY.]

President Lincoln at Home

AFTER A PHOTOGRAPH BY ANTHONY BERGER *1865; engraving.*

The Library of Congress, Washington, D.C.

This touching scene of Lincoln with his son, Tad, appeared in *Harper's Weekly* about a month after the President's death. The illustration was based on a photograph made in 1864—engravings such as this were the only means at the time of reproducing photographic images for a mass audience.

being overcome with the stench of the battlefield corpses they photographed and dodged bullets that might have added their bodies to those already upon the ground.

Some photographers hauled their bulky baggage off to masted navy ships and onto ironclads to record those new marvels of technology and the aquatic struggles in which they engaged. A few even ventured aloft in balloons to record aerial views of battlefields that were helpful in planning strategies. The initiator of aerial military reconnaissance and photography was Thaddeus Lowe of New Hampshire, who called himself the "most shot-at man in the war." In the waning days of the war, Brady photographer J. F. Coonley rode history's first photographic train, an elaborate mobile studio that moved through Confederate-held territory, to make reconnaissance photographs.

The Unmoving Subject

Though undaunted by physical hardship, photographers were limited by something they could not change—the technology with which they worked. Exposures almost always required significant amounts of available light— usually sunlight—and plenty of time—usually several seconds for each exposure. Also, since plates were so fragile, photographers often tried to make at least two versions of each shot. Each photograph, then, required the use of a steady tripod to hold the bulky camera, and subjects willing or able to remain still for some time. For these reasons, photographers were drawn to unmoving subjects, and many Civil War photographs have a static quality to them.

A great many scenes depict landscapes—farmland, woods, homes, and buildings—quiet before or after a battle. Photographers chose such subjects not only because of technological limitations, but also because their visions reflected an American love of the land and appreciation for the finer aspects of country life. Even in war, an idealized image of pastoral harmony was portrayed.[24]

Nonetheless, many images did display corpse-strewn woods and fields, with lifeless heads and hands silent upon the land. Still images of twisted wagons, horse carcasses, ruined houses, and swollen human remains all bespoke the havoc that had gone before. Some of these photographs, static though they were, stirred the deepest emotions. Timothy O'Sullivan's image, *A Harvest of Death*, showing the Gettysburg battlefield strewn with dead men visible in the morning mists, shocked the nation.

Numerous posed photographs include individuals or groups of combatants, standing in camp, clustered near cannons, playing cards, sitting astride their curried steeds, or reclining at rest, all very much aware of the camera's focus upon them. Unposed photographs of the wounded clustered together after a battle or lying miserably in hospitals show little motion yet much pathos.

Large numbers of photographs of the period are simple portraits of ordinary people—hometown families standing stiffly before the lens, mothers and children, soldiers grandly dressed for departure for the front, and military men in camp near battlefields. Small portraits of family members and sweethearts were carried close to the hearts of men in combat, and theirs, in turn, were wept over by wives and children waiting at home. Numerous itinerant portrait photographers conducted brisk business among military men.

A significant number of photographers carried out the official task of copying secret military maps and plans for distribution among field commanders. Gardner, for example, used a large bellows camera on a wooden ramp to copy war documents for the Army of the Potomac. The Army

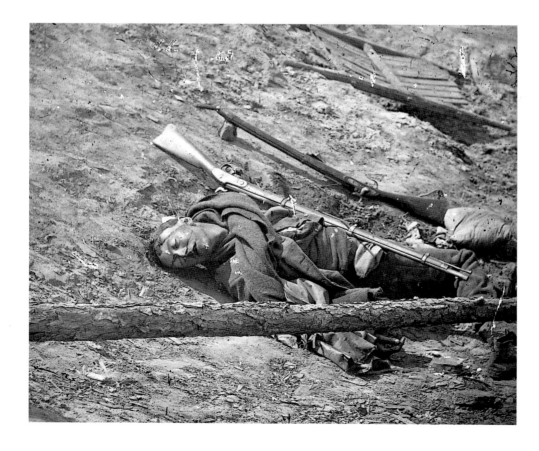

A Dead Confederate Soldier, Petersburg, Virginia

THOMAS C. ROCHE *April 3, 1865; photograph. The Library of Congress, Washington, D.C.* Caught in death between the harsh angle of his rifle and the trunk of a fallen tree, an unknown soldier symbolizes the loss of hundreds of thousands of lives during the Civil War.

Corps of Engineers commissioned many photographic views of bridges, railroads, and other strategic features. The U.S. Military Railroad employed Captain Andrew J. Russell, one of the Union's finest photographers, to run the only government field laboratory.

Despite their noblest efforts, the Civil War photographers could not capture swift actions, since movements left only shadows on the slow collodion emulsions. Even the best cameramen could not record the lurch of a soldier's body at the instant of a bullet's impact, a glistening tear in the eye of a frightened sailor, or the exploding spray of fire and masonry of a fortification struck by a cannon ball. Such vivid, candid images would have to await the development of more mobile cameras, fast shutters, and highly sensitive film. Still, the war photographs suggest and imply action, recording groups of people in conflict, their imposing fortifications and threatening armaments, placid preludes, and frightening aftermaths.

There are few actual action shots made during fighting. Perhaps the best battle picture of the war was made by Alexander Gardner at Antietam on September 17, 1862. From the photographer's perch on an incline near the battlefield, the combatants are largely obscured by the smoke of their raging artillery. As the gunsmoke drifts over horses and caissons ready to join the fray, the photograph grippingly portrays a sense of the desperate battle and its fearsome toll of twenty-six thousand casualties.

Altering Reality

In at least a few cases, accustomed as they were to arranging subjects for photography, photographers unwittingly—and purposefully—altered reality. On a June, 1864, visit to the battlefield outside Petersburg, Virginia, Brady asked the captain in charge if he would set off his cannons for the camera. Brady himself stepped into the picture as the cannons roared. The photograph was made, but it provoked the Confederates to open fire in return.

Brady did not anticipate this result, but Gardner knew what he was doing when he, with the help of others, dragged the body of a rebel sharpshooter forty yards to the lee of a stone wall and arranged it dramatically for his camera. In his *Photographic Sketch Book of the War*, he wrote that he had

Home of a Rebel Sharpshooter, Gettysburg

ALEXANDER GARDNER

July, 1863; photograph.

The Library of Congress,

Washington, D.C.

"What visions, of loved ones far away, may have hovered above his stony pillow!" Gardner wrote of this fallen Confederate, describing coming upon him where he had fallen in this "Sharpshooter's Home." Only years later was it revealed that the photographer and his assistants dragged the body to this spot and added a rifle to dramatically frame the composition.

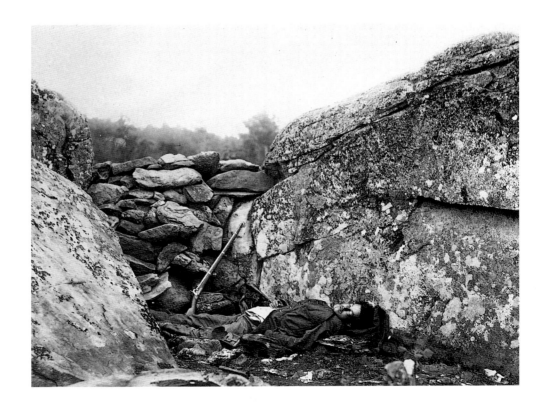

found the body as the photograph portrayed it. Others reported, however, that he had positioned the body and the rifle beside it.

When Lee surrendered at the small settlement of Appomattox Court House, the event happened so suddenly that there was no photographer within forty miles. Later, Brady and O'Sullivan appeared to take a number of pictures of the McLean House, site of the surrender, but without the principals; there was no drama to the scene. Brady then set out for Richmond, where he knocked on the door of General Lee's home. By presuming upon his previous friendship with the gallant leader, and prevailing upon his wife and friends to coax him into it, Brady succeeded in getting the very reluctant Lee to put on his gray uniform one last time to sit for a series of historic portraits.

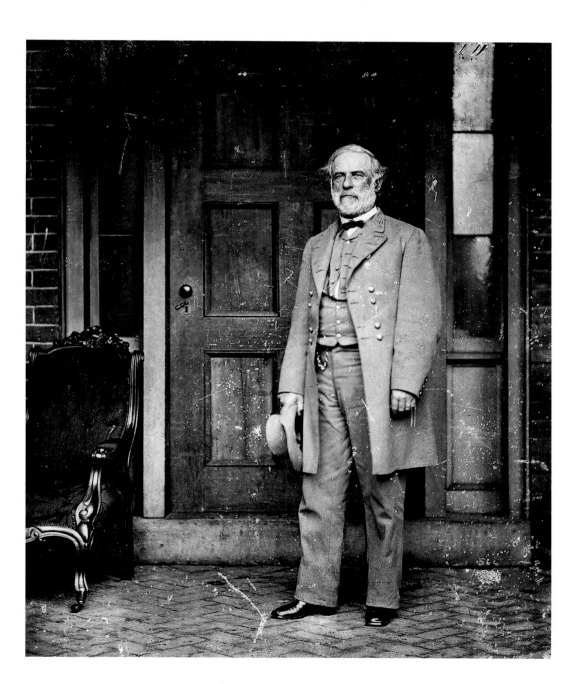

General Robert E. Lee at His Home

MATHEW BRADY *April, 1865; photograph. The Library of Congress, Washington, D.C.* Shortly after his surrender at Appomattox Court House, General Lee reluctantly agreed to step outside his home to pose for Mathew Brady's camera. The portrait reveals the General's tremendous dignity, even in the moment of his military defeat.

**Major General
William
Tecumseh
Sherman**

BRADY STUDIO n.d.;

photograph. The Library of

Congress, Washington, D.C.

A formidable
opponent, the man
who ordered his
troops to cut a
swath of destruction
through Georgia
was not known for a
gentle touch in war.
The general's tena-
cious nature radi-
ates from this photo-
graphic portrait.

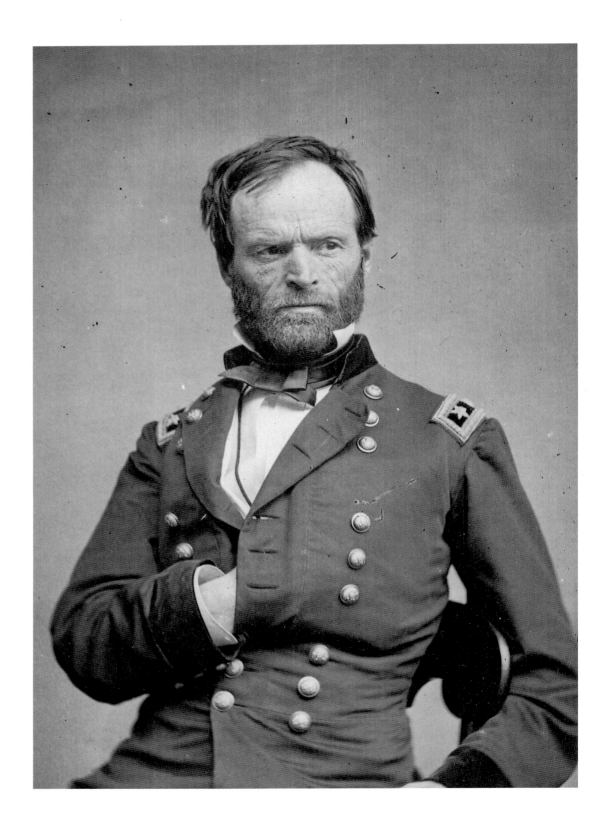

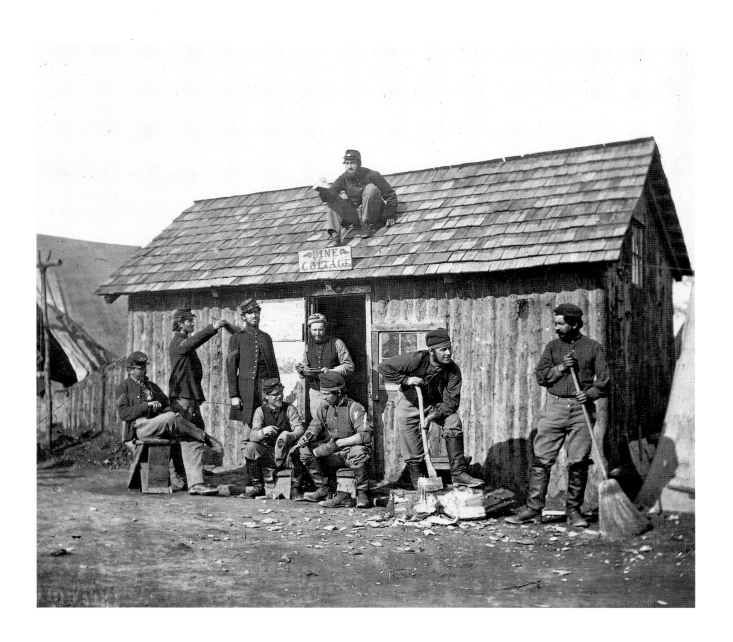

Pine Cottage

UNKNOWN PHOTOGRAPHER *n.d.; photograph. The Library of Congress, Washington, D.C.*

A relaxed group of Union soldiers pose humorously before their "Pine Cottage,"
which was located in the Federal army's winter quarters at Fort Brady, Virginia.

Pitching Horseshoes

WINSLOW HOMER *1865; oil on canvas. Fogg Art Museum, Harvard University,*
Cambridge, Massachusetts.

Relaxing in a quiet moment in camp, soldiers in vivid Zouave uniforms
pitch a game of horseshoes. The realism and detail of this painting can
be compared to similar scenes captured by battlefield photographers. The
distinctive Middle Eastern-style uniforms were associated with fierce French
Colonial troops victorious in North Africa and Europe, and American
Zouaves were noted for their energetic fighting spirit.

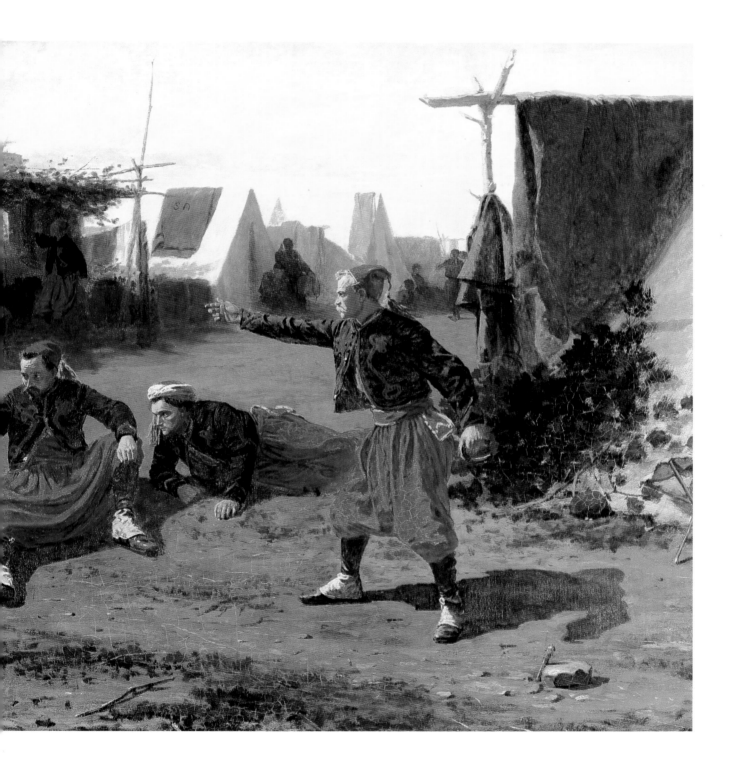

Outrage

Haunting piles of bodies awaiting burial, hands outstretched in search of life where there was none—these images shocked and dismayed viewers experiencing the relative comfort of civilian life. The photographs could not be denied—war was a costly hell, ending forever the lives of the finest young men of the North and the South. Through their pictures, gained through so much effort, the war photographers brought all Americans face to face with the unfathomable realities of war.

Photographs did their part to obliterate romantic or sentimental notions about war. What was truly new in Civil War photography was the depiction of death.[25] Photographing war had been initiated by English photographer Roger Fenton in the Crimea, but none of his 360 images included a corpse. All such unpleasantness was rigorously omitted from any images the British public might have viewed. But American photographers did not shrink from bringing pictures of the dead into the public consciousness. It must be noted, however, that the emphasis of the largely Northern cameramen was on the Confederate dead, and in some respects, images of enemy corpses might have seemed justified to Northern viewers. There was a tendency to depict Union dead, when they were shown, in more serene poses, as if they had recently departed to a just heavenly reward.

Interestingly, the margins between life and death were relatively unexplored by the battlefield cameras. More horrifying than corpses might have been visual documents of violence—men screaming in pain from hideous wounds or having their limbs lopped off in gory medical procedures—but such images do not often appear. Considering the huge numbers of casualties in every battle, even crutches and bandages are underrepresented.

Photographers reflected the attitudes of the majority of the American people and were not, in fact, attempting to stir up the public against the war itself. There was no intent to instigate antiwar protests—and none were forthcoming. Even the critics who wrote so hauntingly of the melancholy emotions engendered by seeing images of the dead went on to imply that the deaths of soldiers were a noble and necessary feature of a just war to save the Union. Viewing the silent images of still, dead men stimulated no outcries against the war and the carnage it wrought. The powerful political forces that prematurely laid the victims in their graves remained unexamined. Seemingly few, in the North at least, asked whether the peaceful coexistence of two countries might not have been better than a Union bought with so much blood.[26]

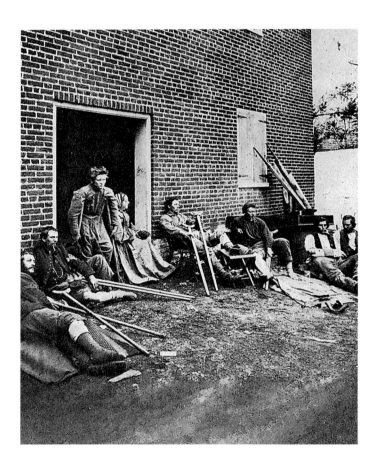

Hospital at Fredericksburg

MATHEW BRADY, OR ASSISTANT *May, 1864; photograph. The New York Public Library.*
Crutches and bandages are the new uniforms of these wounded soldiers at a makeshift hospital in Fredericksburg, Virginia.
A nurse from the U.S. Sanitary Commission sits in the doorway, allowing herself a brief respite from caring for the wounded.

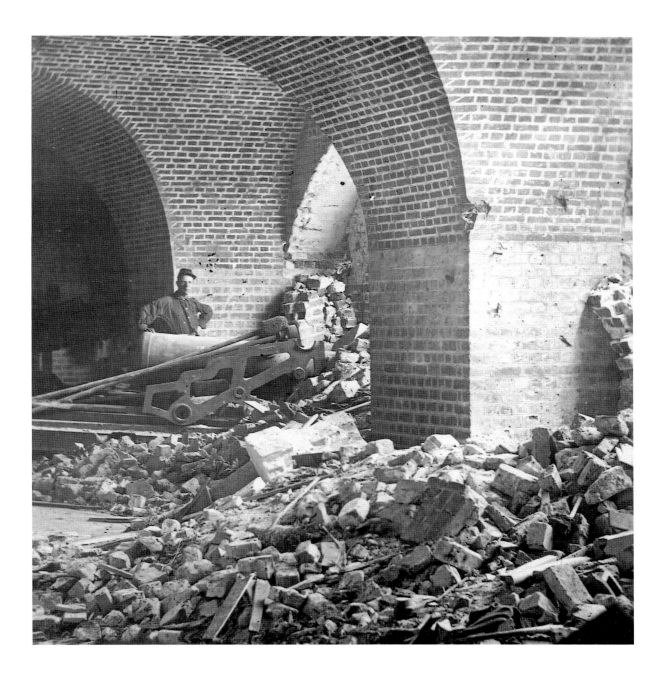

Fort Pulaski, 1862

UNKNOWN PHOTOGRAPHER *1862; photograph.*

The Library of Congress, Washington, D.C.

Scenes of destruction such as this brought home the realities of war to
many people. Romantic dreams of glory evaporated before the evi-
dence of the carnage caused by the world's first industrialized conflict.

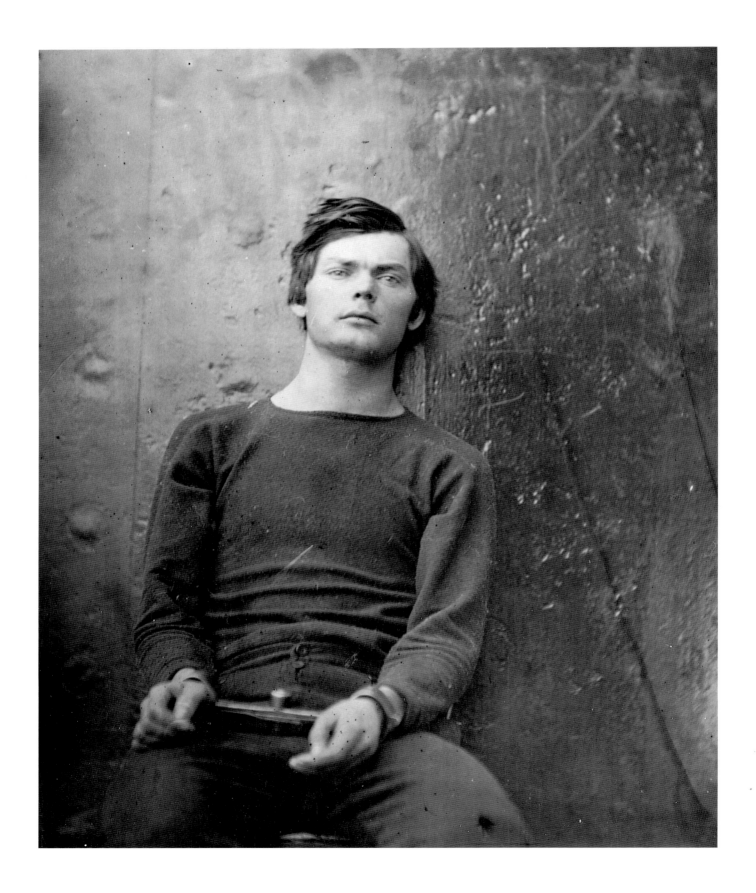

Wartime misery off the battlefield was documented, though inadequately, by the roving lensmen. They did create some poignant images of poor white refugees and some of the thousands of slaves who fled through the Union lines. Portrayed were wagons piled with bedding, chairs, and foodstuffs, drawn by horses, oxen, and mules along rough roads and through waterways, the dazed faces of the dispossessed staring out from beside their wagons.

The photographs which caused perhaps the most outrage were those of prisoner-of-war camps, especially views of the notorious Andersonville prison in Georgia, where a Union prisoner died every eleven minutes. After the Confederate surrender, photographs of the camp were made and published in *Harper's*. A few pictures were general overviews of scruffy tents and indistinct figures, in which the horror of the camp was not fully evident. But close-up portraits of emaciated skeletal survivors were riveting. Such horrible images had never been seen before, and they provoked a huge outcry for revenge. In the autumn following the end of the war, the sadistic Major Henry Wirz, Swiss commandant of Andersonville, was tried for wanton cruelty and murder and sentenced to the gallows. His death was recorded by Alexander Gardner—just four months after Gardner had photographed the hangings of the conspirators in the plot to assassinate his most revered photographic subject, Abraham Lincoln.[27]

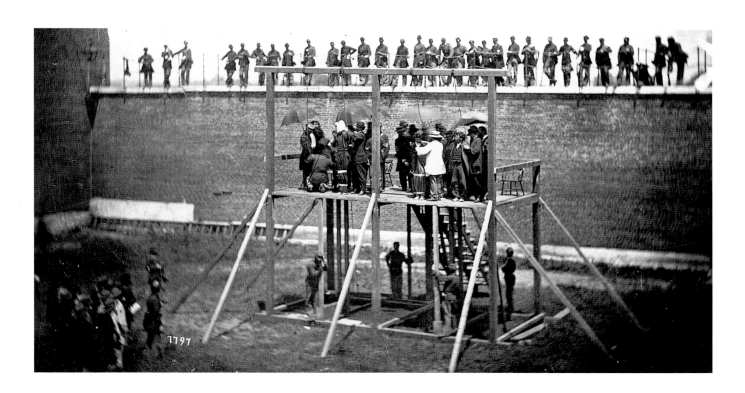

Execution of the Conspirators

ALEXANDER GARDNER *July 7, 1865; photograph.*

The Library of Congress, Washington, D.C.

Four of the conspirators in Lincoln's assassination are prepared for execution at Old Arsenal Prison. Both Alexander Gardner and Timothy O'Sullivan were present to record the deaths with their cameras. The bodies hung motionless in the afternoon heat for thirty minutes before burial near the scaffold.

Lewis Powell

BRADY STUDIO *1865; photograph.*

The Library of Congress, Washington, D.C.

Lewis Powell, alias Lewis Paine, was one of four conspirators hanged in the wake of Lincoln's assassination. His final act was to protest the innocence of Mary Surratt, who died with him.

Procession at Gettysburg

UNKNOWN PHOTOGRAPHER *1863; photograph. The Library of Congress, Washington, D.C.*
A crowd of citizens walks behind a parade of troops on their way to dedicate the new Union cemetery at Gettysburg. It was at this ceremony on November 19, 1863, that Lincoln gave his famous address.

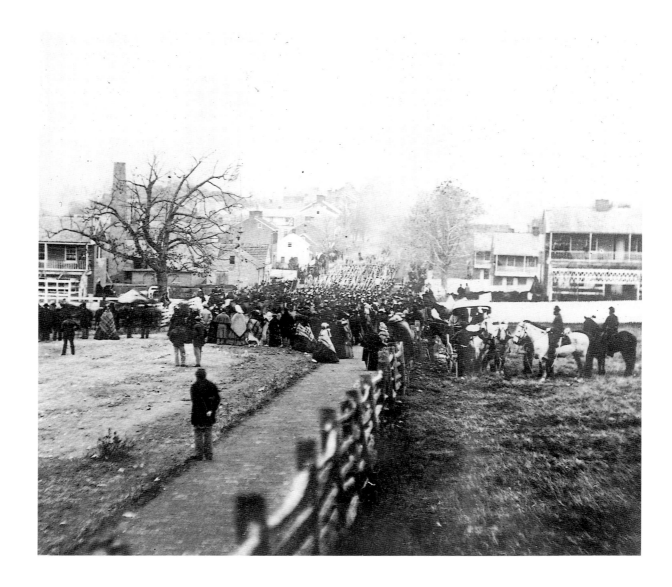

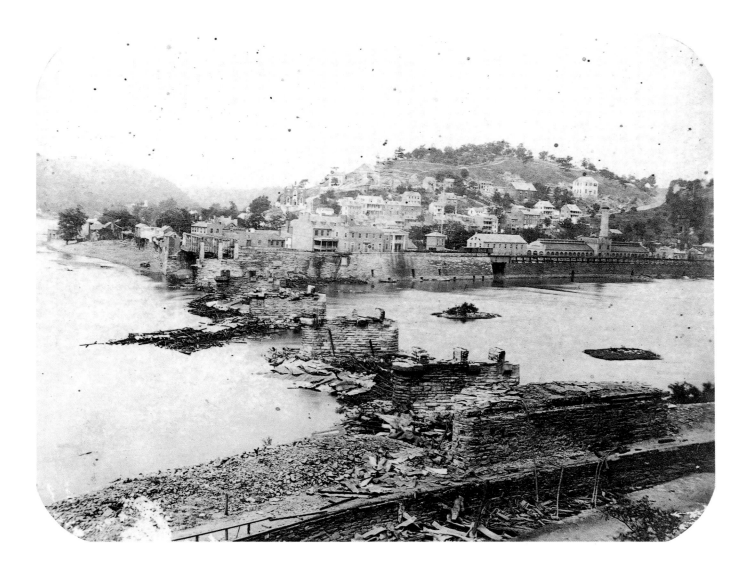

Harper's Ferry

UNKNOWN PHOTOGRAPHER *1861; photograph.*

The Library of Congress, Washington, D.C.

As Rebel forces evacuated Harper's Ferry, West
Virginia, in 1861, they destroyed its railroad
bridges to thwart the invading Federals. During
the Civil War period, this small town, the site of a
major arsenal, repeatedly changed hands.

Wagons Leaving Petersburg

JOHN REEKIE *1865; photograph. The New York Public Library.*

A caravan of Federal supply wagons snakes out of Petersburg to bring
provisions to Grant's troops pursuing Lee. After the ten-month siege of
this vital transportation center in Virginia, the end of the war was at hand.

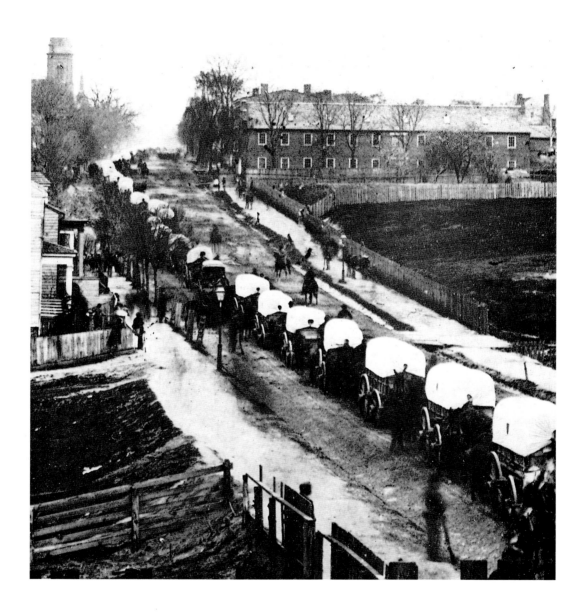

Mourners at Stonewall Jackson's Grave

UNKNOWN PHOTOGRAPHER *n.d.; photograph. Virginia Military Institute Archives.*
General Lee's victory at Chancellorsville was severely
marred by the loss of General Thomas "Stonewall" Jackson,
who died after his arm was amputated following his being
shot mistakenly by his own men. Many mourned, including
groups that gathered around his grave at the Virginia
Military Institute, where he had taught before the war.

Remembering the War

After the close of the Civil War, art became part of the essential process of national healing. A large number of images of the war were produced after the end of the conflict, both because the artists themselves felt the need to create them and because the public wanted to respectly view and preserve such images. The war never let go of the consciousness of those who had borne witness to it, and it has never lost its fascination for the American people, even to this day. In response to the need to deal with the psychic wounds of war in the decades following Appomattox, a vast number of works of art in many media appeared. Through art, Americans sought to move away from the divisions accentuated by the war and toward a vision of national unity.

Healing the Land

The art of national restoration included drawings, engravings, watercolors, oil paintings, photographic exhibits, special albums, publishing projects, and art exhibits of many kinds. Cycloramas—huge panoramic paintings of battles—were commissioned and exhibited throughout the country. The battlefields themselves became works of art of a sort—American landscapes made sacred by the blood of the men who died there. Monuments arose in cemeteries, towns, and cities. Cannons and mortars were polished and displayed. Memorial structures to honor military and political leaders appeared on their graves, in the nation's capital, and in other significant locales. Museums garnered and exhibited war memorabilia.

Photographers recorded veterans' gatherings, and homes to care for aging veterans were built. Civil War battles were reenacted, and thousands of books on the war and on Lincoln were published. The production of art pertaining to the war has continued well into the modern era.

Refined Images of Conflict

Many of the combat artists moved on to other subjects after the war, for it had been an overwhelming assignment. Some, particularly amateur artists, returned to their civilian lives. Others traveled to the West, where national expansion resulted in the opening up of new areas of physical beauty, appealing subjects for an artist's eye. William Cullen Bryant's highly successful publishing venture, *Picturesque America*, utilized images created by onetime war artists.

Many wartime artists continued to produce images of the war after the conflict had ended. For some, war images were a sideline, while for others, they became a life's work. Edwin Forbes is perhaps most notable for his continued concentration on Civil War images throughout his career. He spent many years working on pictures derived from his battlefield sketches. Visual themes, once hastily drawn in the heat of battle or by lamplight in his field tent, were now expanded into finely wrought pen-and-ink drawings and paintings.

In 1876 and 1890 Forbes published two sets of engravings based on his field sketches—*Life Studies of the Great Army* and *Thirty Years After: An Artist's Story of the Great War.* In these he gave short shrift to battlefield drama and instead concentrated on the routines of army life, the exhaustion of long marches, the solitude of sentinel duty, and the performance of veteran troops under fire.[28]

The Wounded Drummer Boy

EASTMAN JOHNSON *1871 ; oil on canvas. The Union League Club of New York.*
The drummer boy was a sentimental figure in many pictures and writings about the Civil War. The fact that young boys were so close to the tragedies of war gripped adult imagination. In Johnson's melodramatic portrayal, a wounded boy drums through a battle as he is carried by a soldier from his regiment.

Battles and Leaders

The most significant postwar publishing project which depended heavily on the contributions of wartime artists was conceptualized by the editors of *Century* magazine.[29] Nearly two decades after Lee's surrender, the magazine editors began assembling firsthand accounts of all the major campaigns and battles of the war from officers and soldiers of all ranks of the Union and Confederate forces. To accompany these writings, the editors commissioned illustrations from artists of the war. No longer rushed by time and circumstance, the artists carefully prepared images to be painstakingly rendered by skilled engravers.

These illustrated accounts were published in issues of the magazine, serialized for three years. Finally, they were issued in 1888 in four thick volumes—the remarkable *Battles and Leaders of the Civil War.* The results were still imperfect versions of the artists' original works, since engraving remained the method of reproduction. However, about a thousand pictures produced by some seventy artists made available a new series of excellent images of the war.

Artists employed for the project included the well-known "special" field artists Alfred Waud, Theodore Davis, and Frank Schell, along with Allen Redwood, who provided pictures of the Confederate army, with which he had fought. Edwin Forbes, William Shelton, William Sheppard, Xanthus Smith, and William Waud were among the other well-known contributors. Nearly 250 illustrations in the volumes are credited to Walton Taber, about whom little is known. Considering his large volume of work, it is probable that he was a longtime staff artist for the Century Company. Thure de Thulstrup, a Swedish-born

Assault on Vicksburg, 1863

THURE DE THULSTRUP *1889; watercolor. Seventh Regiment Fund, Inc., New York.*
A deadly hail of grapeshot and cannon balls greets Union attackers at Vicksburg's Fort Beauregard. A sergeant advances to plant his regiment's colors, but the invaders are driven back. The paintings of the Swedish-born de Thulstrup are known for their power to portray Civil War action. He understood the American Civil War well, although he did not emigrate to North America until 1873.

veteran of the Franco-Prussian War, also produced images for the volumes.

All over America, Civil War veterans and their families pored over these volumes, which sparked renewed interest in the war at a time when memories were beginning to fade and when the postwar generation was reaching adulthood.

In 1895 another impressive work was published, *Frank Leslie's History of the Civil War*, full of beautiful large-sized Civil War engravings.[30]

Photographic Memories

After the guns were silenced, Civil War photographers remained busy for a time. Their new subjects were veterans, some crippled, some decorated, all proud of having survived their wartime experiences. Heroes crowded into Washington for a Grand Review up Pennsylvania Avenue, and Mathew Brady and his assistants captured their images for all time. (The Review of the Grand Army of the Republic also inspired several painters.) Following his own longtime precedent of never taking "no" for an answer, Brady and his assistants went through heroic efforts of their own to assemble Union General William T. Sherman and all his staff for a studio portrait.[31]

Alexander Gardner was particularly active in the days after the war. In addition to photographing what he could of Lincoln's funeral and the executions of the assassination conspirators, Gardner's camera recorded the dedication of the monument at Gettysburg and Sherman's men marching in the victory parade. He also managed to photograph the feminine dress in which Confederate president Jefferson Davis had tried to escape from Union captors—Gardner had an officer model the clothes for his sensational photograph.

During the war, Brady published his *Album Gallery* and *Incidents of the War*. In 1866, Alexander Gardner produced his beautiful two-volume *Photographic Sketch Book of the War*, which contained one hundred mounted photographs and was the first published collection of Civil War photographs. (Without permission, Brady added Gardner's images to his own collection.) Unfortunately, since each of Gardner's prints had to be individually made, the cost of each set was $150, and the venture was a commercial failure. Only five copies of the original are known to have survived, but modern reprints exist. Over half of the negatives in Gardner's book were attributed to Timothy O'Sullivan. Also in 1866, George Barnard produced a deluxe collector's edition, *Photographic Views of Sherman's Campaigns*. Andrew Russell apparently produced a small number of scrapbook-type albums entitled *United States Military Railroad Photographic Album*, a few copies of which were located in recent decades and in 1982 was reprinted.

Not long after the war, interest in these photographs diminished. Some of the pictures had made grim viewing during the conflict itself, and after the war there was a growing desire to let the tragedies that had affected so many slip from

The Andrews Raid: Confederates in Pursuit, 1862

WALTON TABER *1886; ink drawing. American Heritage Century Collection, New York.*

The excitement of "The Great Locomotive Chase" in the spring of 1862 is captured in this sketch of Confederates in hot pursuit of James Andrews and his men driving the stolen locomotive *General* on a mission of destruction in Southern territory. The relentless Rebels caught and eventually imprisoned or executed the raiders.

The Grand Parade of
Sherman's Army in Washington

JAMES E. TAYLOR *1881; watercolor on paper. The Ohio Historical Society.*
Crowds gathered to hail the victors as they marched
down Pennsylvania Avenue in a grand procession after
the war. Photographs of the event depict the actual
scene—though in black and white—while paintings catch
in rich detail the colorful excitement of the war's end.

**Lincoln's
Drive Through
Richmond, 1865**

DENNIS MALONE CARTER
*1866; oil on canvas, Chicago
Historical Society, Illinois.*
In this romantic,
Northerner's view,
Lincoln rides through
conquered Richmond
with throngs welcom-
ing him on every side.
Actually, while freed
slaves were enthu-
siastic, most white
Confederates turned
away with revulsion
from Lincoln's en-
tourage. The ruins
of the city frame
the imagined scene.

Furling the Flag

RICHARD NORRIS BROOKE *1872; oil on canvas. West Point Museum, U.S. Military Academy.*
Furling the Confederate flag for the last time, as news of Lee's surrender
reaches them, Southern soldiers and a drummer boy weep with sorrow.
The flag, like the combat veterans, bears permanent battle scars. Some
shod, some barefoot, all must return home now to a changed world.

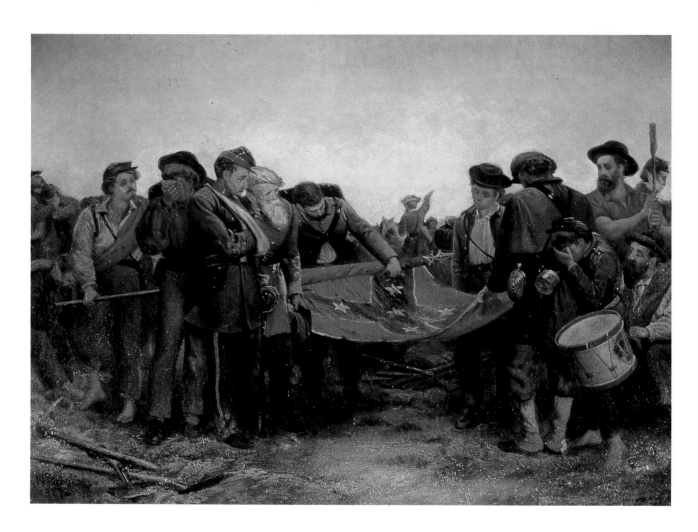

memory. Images of haunted faces, piles of bodies, and heaps of skulls were difficult to look at. The nation sought unity, and trying to forget the harsh details of the cruel wartime events was part of the process. It remained for later generations to fully appreciate the merits of these excellent photographs.

For a while, Brady, Gardner, and the other wartime photographers took their cameras to the silent battlefields, the installations of more monuments, and the continuing gatherings of surviving veterans. But ultimately they had to move on. Both Gardner and O'Sullivan closed their East Coast galleries and went West to photograph the expanding frontier. They were part of a group of enterprising photographers who recorded the scenic wonders of the American West, Central America, and South America.

A great many war photographs were treasured, particularly those of historic events and eminent leaders. Some of the most famous portraits, particularly of Lincoln and Lee, skyrocketed in value and became the centerpieces of important collections. The fate of thousands of lesser-known images was not so favored.

Not long after the war, Brady fell on hard times. Creditors seized many of his negatives and issued prints from them under their own names. In 1875 Brady's negatives were sold to the government. Brady himself, virtually penniless, collapsed and died in 1896 at the age of seventy-two.

In 1912 a dedicated collector named Frederick Meserve visited the War Department in Washington, where the collection was being held. He obtained three thousand prints but was horrified to find more than fifty of Brady's priceless daguerreotypes rudely tossed on the floor. Because of his interest, some of these were saved. In other instances, unknown numbers of glass negatives were carelessly smashed and swept into the garbage. Large numbers of Brady's negatives were eventually garnered by the National Archives and the Library of Congress, where they are carefully tended.

Gardner died of "a wasting disease" in 1882; some of his images, too, are preserved in government archives. Unfortunately, many of his priceless negatives met a tragic end. Thousands were deliberately smashed with a hammer by an insane heir and thousands more were cleansed of emulsion by a dealer salvaging glass and silver.

Another heir burned boxes of Gardner's papers and photographs.[32]

A few major collectors worked together to save important images, and several impressive volumes of Civil War and Lincoln photographs were produced, with actual photographic prints mounted on the pages. Meserve's twenty-eight volume set, *Historical Portraits*, was priced at $5,000 per set in 1917. In the early 1940s, Meserve aided Carl Sandburg's efforts to illustrate *The Photographs of Abraham Lincoln*, published to an enthusiastic reception.

Heroic Paintings

The public wanted pictures of the war, but they desired the reality of the conflict to be made prettier and more heroic than it could appear in photographs. Glorifying the deeds of the surviving and the dead became a necessary goal for painters who pictured the war long after the smoke had cleared from the battlefields.

There was great demand for semi-documentary paintings of particular regiments, requested by members of the regiments as souvenirs. Then there were orders for more ambitious military paintings to illustrate publications and adorn

Rescue of the Colors, 1861

WILLIAM T. TREGO *1899; oil on canvas. Mercer Museum, Bucks County Historical Society, Pennsylvania.*

At the Battle of Fair Oaks (or Seven Pines), Pennsylvania troops launched a valiant counterattack. Here, clutching his own flag, a color sergeant rushes to rescue the banner of a fallen soldier. William Trego was severely impaired by polio and was not a combatant, but he captured the immediacy of the action in this carefully painted composition.

public buildings, soldiers' homes, and veterans' associations. The paintings would become colorful adjuncts to memory as well as potent weapons in the continuing discourse about rights and wrongs in the war. Some paintings of great artistic significance were produced during the war itself, but a larger number of important images were painted in the ensuing decades. In contrast to the wartime sketches and photographs, many of these paintings were distant from the realities of the war both in time and in their romanticizing of the conflict. Some artists borrowed from European traditions of battle art, quite inappropriate for American conditions. In fact, some artists were actually European. For American viewers of the paintings, however, they could often be very moving indeed.

The paintings made after the war were not alone in their glorification of military deeds. Early in the war, some artists had a tendency to portray leaders in grand equestrian style. Many paintings focused on flags—colorful, swirling symbols of the combatants over whom they waved. In other paintings, made during and after the war, leaders struck valiant poses, which were often quite different from those in actual battle conditions, when

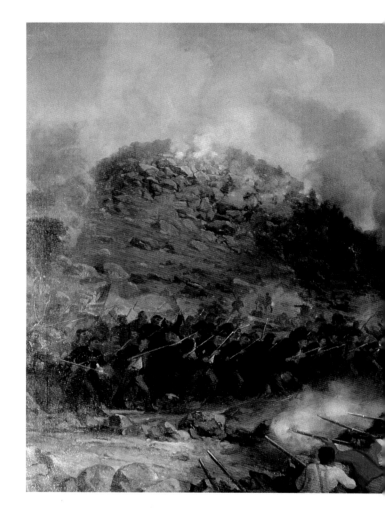

Sheridan's Ride, October 19, 1864

LOUIS PRANG & CO., AFTER THURE DE THULSTRUP *1885; chromolithograph.*

The Lincoln Museum, Fort Wayne, Indiana.

General Philip Sheridan rides dramatically past his troops, inspiring them to fight for victory at the Battle of Cedar Creek in Virginia. Sheridan's Ride on his night-black steed was immortalized in art and literature, giving him a hero's status throughout the North. Military artist Thulstrup's painting was the model for Prang's popular version of the thrilling event.

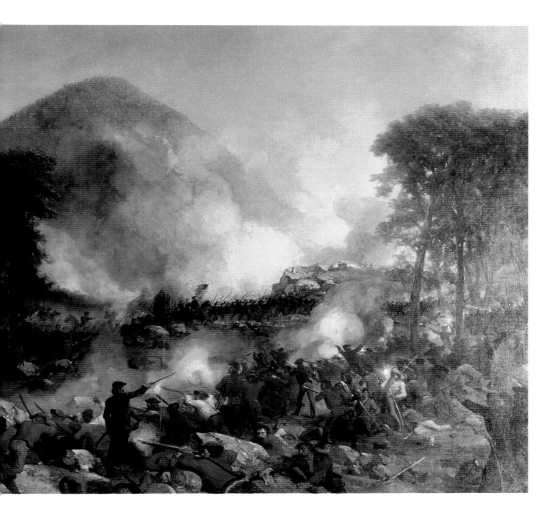

Fighting at Plum Run Valley, Gettysburg, July 2, 1863

PETER FREDERICK ROTHERMEL

1870; oil on canvas. Collections of the State Museum of Pennsylvania. Fighting men at Gettysburg face each other just yards apart, as Pennsylvania troopers charge into Plum Run Valley against Confederate General Longstreet's corps. The vital hillocks Little Round Top (left) and Big Round Top (center) loom above. After exhaustive research, Rothermel produced an epic series of five canvases of Gettysburg.

commanders frequently kept to the rear so they could issue orders from a relatively safe location.

Some painters went to extremes to try to portray their subjects accurately. James Walker worked on his twenty-foot canvas of Gettysburg for five years, spending long hours at the site and interviewing survivors. The soldiers, nobly riding on horseback or lying stunned upon the ground, all seem real, yet in the beautiful golden light of the painting, the true horror of the event is lacking.

Another painter of the Gettysburg drama was Pennsylvania-born Peter Frederick Rothermel, an experienced historical artist. He too spent years studying his subject, tramping Gettysburg's fields with veterans of the combat, traveling thousands of miles to interview soldiers and sketch their faces. His resulting five large canvases are remarkably accurate in detail and atmosphere.

Paintings of the surrender of General Lee to General Grant at Appomattox Court House are very much marred by inaccuracies, since no artist was on hand to witness the momentous event. The two generals are sometimes shown seated at the same table, but eyewitnesses reported that they sat at separate tables. General Grant, who was turned out rather shabbily for the occasion in comparison to the sartorial Lee, is often depicted in sharper garb than he actually wore.

Depictions of Abraham Lincoln's last hours are sometimes even more absurd. After the shooting at Ford's Theater, the dying Lincoln was rushed across the street to a rooming house, where he died the next morning. In one painting, nearly fifty people are shown clustered around the dying president. In actuality, the tiny bedchamber where Lincoln died could hold only a handful of people.

Cycloramas

In the latter decades of the nineteenth century, the American desire both to remember the war and enjoy a spectacle meshed in the popularity of cycloramas, large panoramic paintings of Civil War events displayed in special cylindrical buildings.[33] These huge battle scenes provided the public with an immersion experience in some of the battles of the Civil War, and huge crowds gathered in various cities to pay 25 or 50 cents admission to the special exhibits.

The military panorama was a European art form popular from about 1785 to 1903. Panoramas had been brought from Europe to the United States since 1790 and had toured the country, displayed in specially-designed buildings. Wrapped around the interior wall of a round building, the huge painting—typically about 400 feet long by 50 feet high—gave the viewer standing in the middle of the viewing chamber, surrounded on all sides by the dynamic image, a feeling of actually being at the scene of a battle. Because of their huge size, cycloramas vividly represented the enormity of the actual landscape as well as the fine details of the unfolding military events.

The finest cycloramas were painted by European artists well trained in the medium. The Vicksburg cyclorama, for example, advertised as the first panorama representing an episode of the Civil War, was painted by Joseph Bertrand and Lucien Sergent of Paris. Bertrand came to the United States and visited for several months at the Vicksburg, Mississippi, battlefield, making sketches, consulting official maps, and discussing details with veterans. He returned to Paris and spent eighteen months painting his grand work of art. The cyclorama depicted Grant's assault on Vicksburg on May 22, 1863, with the spectator ostensibly standing on a Confederate redoubt near the center of the Union lines. During a four-year tour of the United States, several million visitors flocked to view the painting. Unfortunately, its whereabouts today are unknown.

Other famous cycloramas portrayed Second Bull Run, the Storming of Missionary Ridge at Chattanooga, the battle between the *Monitor* and the *Merrimack*, the Army of the Cumberland, the Battle of Shiloh, the Great Locomotive Chase (Andrews' Raiders), and scenes from the Battle of Antietam. Most of these have disappeared or are not on display today. However, the full cycloramas of the Battle of Gettysburg and of the Battle

The Gettysburg Cyclorama: Pickett's Charge, 1863

PAUL PHILIPPOTEAUX *1884; oil on canvas. Gettysburg National Military Park, Pennsylvania.*

The spectacle of battle at Gettysburg is dramatically depicted in this huge panoramic painting prepared by French artist Philippoteaux and his assistants. In this panel of the painting, General Lee launches 15,000 infantrymen in a climactic—and ultimately doomed—attack against General Meade's Federal forces. The artist worked from information he gathered at the site and from numerous interviews with survivors of the famed battle.

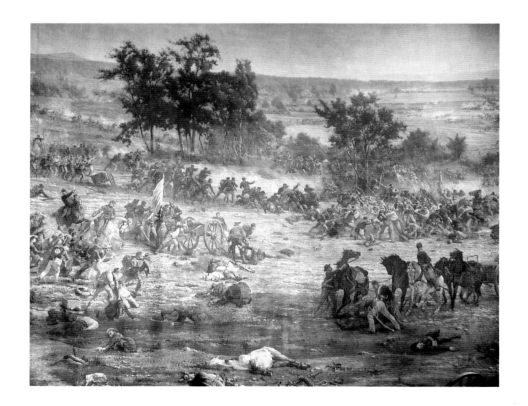

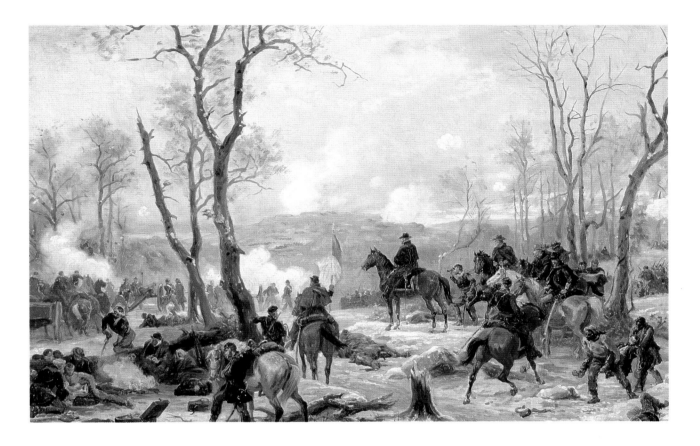

General Grant at Fort Donelson

PAUL PHILIPPOTEAUX *n.d.; oil on canvas. Chicago Historical Society, Illinois.*
Blood spills on white snow as General Grant stares
somberly at Fort Donelson, under bombardment by his
artillery. Philippoteaux, a painter best known for his enor-
mous cyclorama canvases, here presents a more intimate
view of war—from the point of view of the commanding
officer responsible for the casualties that surround him.

of Atlanta can currently be seen in modern view-
ing facilities near the locations where the battles
occurred.

The Cyclorama of the Battle of Gettysburg was
painted by Paul Philippoteaux, who honed his
skills under the tutelage of his father when they
painted a cyclorama of the Franco-Prussian War
of 1870–71 in addition to eight other European
cycloramas. Philippoteaux began to research the
Gettysburg composition around 1882 by visiting
the area, having panoramic photographs of the
battlefield taken from a special tower, studying
maps, and consulting with generals and heroes.
He worked with five assistant artists in complet-
ing the painting in Paris. The resulting canvas, 375
feet in circumference by 25 feet high, required
over four tons of paint. It portrays the staggering
drama of Pickett's Charge from the point of view
of the Union lines looking out toward the
Confederate forces. The painting was such a suc-
cess in America that the artist was commissioned
to do several copies, each of which drew thou-
sands of paying visitors.

The Atlanta Cyclorama was produced by
William Wehner and his European team at the
American Panorama Studio in Milwaukee.
Theodore Davis, the famous battle artist, guided
the painters around the battlefield and pointed
things out from a special viewing platform.
Veterans of the battle were also interviewed.
Within two years the canvas, 358 feet by 42 feet,
was ready for viewing. It was first shown in
Minneapolis in 1886 but eventually found a per-
manent home in Atlanta. Union General John A.
Logan, from southern Illinois, is featured as the
hero of the piece—which depicts the events of

July 22, 1864—because it was he who commissioned the work for $42,000. Despite the sweltering 102° F. heat of the actual day of the battle, Logan is portrayed wearing full military dress, including padded coat and gauntlets.

The Atlanta Cyclorama was embellished by three-dimensional plaster figures of soldiers, cannons, and wagons, plus genuine earth, shrubs, and rocks, all added during the Depression by WPA artists. The natural elements were eventually replaced by fiberglass materials and the painting was fully restored in an $11 million project completed in 1982.

Monuments in Stone and Bronze

The American desire for national reconciliation was interwoven with the wish to memorialize the heroic efforts of the North and the South by means of erecting tangible monuments in marble, granite, and bronze. Throughout the states of the newly reunited nation there arose thousands of structures to commemorate the exploits of the survivors and the dead of the Civil War.[34]

The sheer numbers of these monuments are overwhelming. In a pictorial catalogue of Confederate monuments, Ralph Widener, Jr. describes and documents a total of 1,105 monuments in twenty-five states and the District of Columbia. In a detailed study, art historian Michael Panhorst discusses more than 2,300 monuments, memorials, and markers standing in Civil War battlefield parks, most dedicated between 1885 and 1917.

For many decades after the war, sculptors, architects, artisans, entrepreneurs, and workers in the monument industry were kept busy with scores of private and public commissions. Structures created shortly after the war focused on memorializing the dead, while later monuments stressed themes of national reconciliation and unity.

Civil War memorials exist in an enormous range of artistic styles, themes, and materials, and they adorn cemeteries, the grounds of public buildings, parks, and battlefield sites. Most numerous are realistic statues of ordinary soldiers; other common monuments are stone obelisks reminiscent of Cleopatra's Needle or the Washington Monument. Equestrian statues of military leaders abound, and there exist metal plaques, carved boulders, cannons, sundials, busts, tombs, fountains, arches, pillars, bells, and stained-glass windows. Some elaborate statuary includes Winged Victory figures, surging combatants, and waving flags. Most stupendous of all is *The American Soldier,* a heroic 21-foot-tall figure, installed in 1874 at Antietam to commemorate what is remembered as America's bloodiest day.

Thirty Civil War sites are administered by the National Park Service, including such notable locations as Appomattox Court House, Ford's Theater, Fort Sumter, Andersonville, and Antietam. Hundreds of other sites related to the Civil War are maintained by various organizations. In many places, the now-peaceful fields of battle are themselves maintained as memorials to those who fought there, the trees and grass manicured only enough to keep them from becoming a wilderness.

Memorializing the Leaders

The greatest leaders of the Civil War are remembered in notable memorial structures. General Robert E. Lee is buried in a pillared chapel known as "The Shrine of the South" at Washington and Lee University in Lexington, Virginia. A more grandiose monument to Lee stands at Stone Mountain, Georgia, where his equestrian figure is carved alongside figures of Jefferson Davis and Stonewall Jackson onto the face of the granite mountain in a panel 90 feet tall by 190 feet wide. The sculpture was begun by Gutzon Borglum, who carved Mt. Rushmore, and was finished by Walker Hancock.

General Ulysses S. Grant is buried with his wife in a grandiose pillared and domed structure known as Grant's Tomb, on Riverside Drive in New York City. More than ninety thousand people

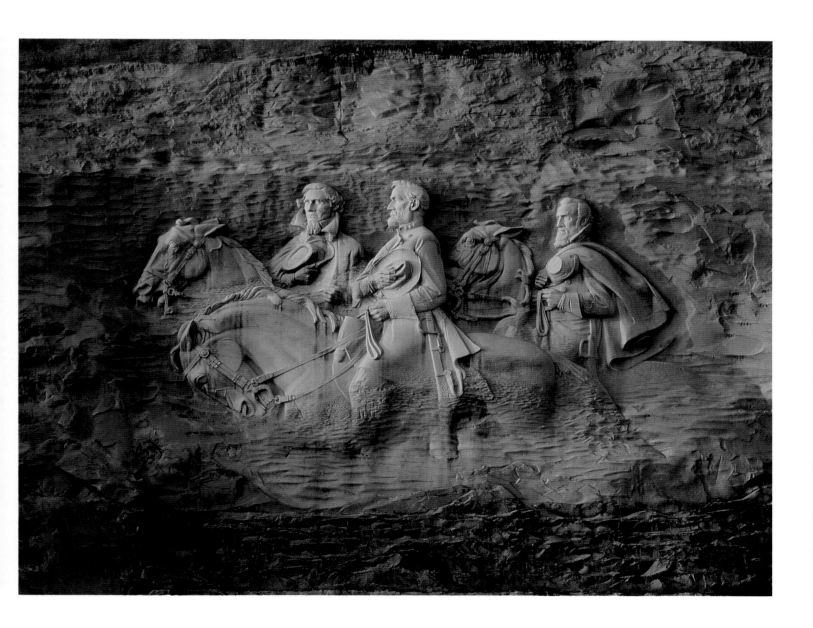

Confederate Leaders, Stone Mountain, Georgia

GUTZON BORGLUM AND WALKER HANCOCK *1923–69; granite bas-relief. Stone Mountain, Georgia.*
Magnificent equestrian figures of Confederate heroes of the Civil War
ride across the face of Stone Mountain. Carved into solid granite by the
sculptor of Mt. Rushmore are the likenesses of Jefferson Davis, "Stonewall"
Jackson, and Robert E. Lee, Southern leaders never to be forgotten.

donated $600,000 to build the stone monument, completed in 1897.

Abraham Lincoln's tomb rises grandly 117 feet atop a hill in Oak Ridge Cemetery in Springfield, Illinois. A large granite obelisk is dramatically flanked by heroic bronze statues representing the Civil War military services, and a larger-than-life-size bronze bust of the president by Gutzon Borglum stands before the entrance, its nose shiny as a result of visitors rubbing it for luck. Inside the tomb are fine bronze figures of Lincoln at various stages in his career, surrounded by some of his most memorable words cast in bronze. The design, by Larkin Mead, symbolizes

Lincoln's role in the preservation of the Union and was selected in 1868 from among thirty-seven submitted. Lincoln's body, once the object of a theft attempt, lies under the monument, beneath tons of concrete and stone. Members of his family are buried with him. Construction of the tomb was funded with $171,000 in private donations and state funds.

Perhaps the most widely admired monument to a Civil War figure is the Lincoln Memorial in Washington, D.C., designed by Henry Bacon, and dedicated in 1922. Magnificently situated overlooking the Mall and the Potomac River, the massive white marble building is surrounded by thir-

The Lincoln Memorial

HENRY BACON *1922; Washington, D.C.*
America's most widely revered memorial to a leader of the Civil War
is the Lincoln Memorial, grandly situated overlooking the Mall in the
nation's capital. Millions of visitors find inspiration here each year.

ty-six Doric columns—one for each state in the Union at the time of Lincoln's death. In the center of the open hall sits a majestic statue of Lincoln by Daniel Chester French, portraying in stone the strength of character of the man who led the divided nation back to union.

Peaceful Unity

Artistic depictions of the Civil War continue to hold great power for Americans. Every year thousands visit historic monuments, purchase publications and images portraying the various struggles, and view movies and television programs depicting the tragic strife.

Today, as in the past, Americans willingly invite the Civil War, with all its disturbing agonies, into their hearts and homes. They do this because, by looking at images of the conflict that tore the nation apart, they realize yet again the importance of maintaining national unity, not only politically but emotionally as well.

Through the many works of visual art inspired by the American Civil War—the numerous paintings, drawings, photographs, monuments, and documentary assemblages of a multitude of images—the profound tragedy of that conflict, and, alternatively, the supreme beauty of harmonious peace, can begin to be understood.

Abraham Lincoln

DAVID CHESTER FRENCH *1922; marble sculpture. Washington, D.C.*
Inside the Lincoln Memorial, a magnificent seated figure of Abraham Lincoln, carved in white marble, looks out over the capital city. The sculpture is larger than life yet retains an intimate quality to which visitors to the Memorial can relate.

**Defending Little
Round Top, 1863**

PETER FREDERICK ROTHERMEL

*1869; oil on canvas. Collections of
the State Museum of Pennsylvania.*

A New York rifleman takes
aim against Texan attackers at
Gettysburg on the western face
of Little Round Top. Sulfurous
fumes, shouts, and groans filled
the air during the vigorous battle,
which ended in a Confederate
rout. As depicted here, men and
rocks seem united in the struggle.

Fall of the Leaders, 1862

WALTON TABER *1886; ink drawing. American Heritage Century Collection, New York.*
The gallantry of horse-drawn artillery forces was often essential to the success of the infantry. At the Battle of Fredericksburg in Virginia, illustrated here, Captain John Hazard's Rhode Island battery rushed to the aid of the foot soldiers, losing many men and horses in their vital effort.

Holding the Line at All Hazards

GILBERT GAUL *1882; oil on canvas. The Birmingham Museum of Art,*
Alabama.

Wounds and death do not deter this courageous band of
Confederates fighting Union attack. Bright red blankets and
the waving Confederate flag represent the soldiers' vigor
in the face of enemy fire. The realistic portrayal almost
makes the viewer feel a part of the action. The painting won
a gold medal in 1888 from the American Art Association.

Attack on Culp's Hill, Gettysburg, July 3, 1863

PETER FREDERICK ROTHERMEL *1870; oil on canvas. Collections of the State Museum of Pennsylvania.*

A black dog, mascot of the 1st Maryland regiment, rushes ahead of
the men charging Federal defenders at Culp's Hill in Gettysburg.
Years of careful research informed Rothermel's masterful painting of
the charge, in which thirty-one Southerners—and the dog—perished.

Kearsarge Gun Crew, 1864

WALTON TABER *1886; ink drawing. American Heritage Century Collection, New York.*

In their tide-turning battle against the Confederate ship
Alabama, the gun crew of the *Kearsarge* fired their 11-inch
pivot guns to good effect. In his dynamic sketch, Taber
catches the men rejoicing as the Rebel raider sinks.

Storming Fort Wagner

LOUIS KURZ AND ALEXANDER ALLISON *1890; chromolithlograph. Art Brown Collection.*

Heroic black Union troops charge toward destiny in the 54th Massachusetts
Volunteer Infantry's dramatic 1863 assault on Fort Wagner in South Carolina. Led by
white commander Col. Robert Gould Shaw, here depicted at the moment of his death,
the regiment failed in its military objective but won a political and moral victory for
African American fighters. The episode was featured in the popular 1989 film *Glory*.

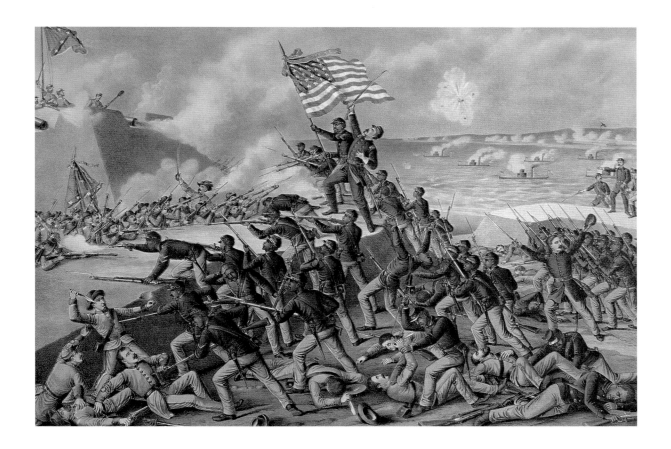

**An August Morning
with Farragut:
The Battle of Mobile
Bay, August 5, 1864**

WILLIAM HEYSHAM OVEREND

*1883; oil on canvas. Wadsworth
Atheneum, Hartford, Connecticut.*

To close Mobile Bay to
shipping, Admiral David
Farragut led a Union
flotilla of eighteen vessels
to victory against a
Confederate fleet. In this
unusual painting, focusing
on the intensity of the
crew rather than the
exterior of the ship,
Farragut leans out to face
the fearsome *Tennessee*,
the largest ironclad afloat.

Notes

1. Information in this chapter is derived from a large number of sources. Estimates of the number of Civil War dead vary.
2. Pratt, *Civil War in Pictures*, p. 15.
3. This section draws upon numerous sources, including Garrett *et al.*, *The Arts in America*; Craven, *American Art, History and Culture*; Flexner, *The World of Winslow Homer*; and Sears, *The American Heritage Century Collection of Civil War Art*.
4. This section draws upon numerous sources, particularly Stern, *They Were There*; and Sears; as well as Pratt, and McPherson *et al.*, *Time-Life History of the Civil War*.
5. Information on the Waud brothers is derived from many sources, especially Ray, *Alfred R. Waud: Civil War Artist*.
6. Ray, pp. 35, 42–43.
7. Davis, "How a Battlefield is Sketched," pp. 661, 668.
8. Information on Forbes is derived from, among other sources, Forbes, *Thirty Years After*; McPherson *et al.*, pp. 340–341; Pierce and Smith, *Citizens in Conflict*; and Dawson, *A Civil War Artist at the Front*.
9. Chapman's life is summarized in Pierce and Smith.
10. The activities of various artists are described in Thompson, *The Image of War*; Sears; and several other sources.
11. Billings, *Hardtack and Coffee*; illustrated by Charles W. Reed.
12. This section relies upon Stern; Sears; Flexner; Wakeman, *Victorian Book Illustration*; and Simon, *The Story of Printing*, among others.
13. Craven, p. 230–231, Pierce and Smith, p. 23.
14. Holzer and Neely, *Mine Eyes Have Seen the Glory*, pp. 217–221.
15. See Cullen, *The Civil War in Popular Culture*, p. 193; and Moore, *Women of the War*.
16. Much of this information derives from Thompson; see particularly pp. 103–07.
17. This section draws upon Craven; Holzer and Neely; Flexner; Grossman, *Echo of a Distant Drum: Winslow Homer and the Civil War*; Simpson, *Winslow Homer: Paintings of the Civil War*; and Wood and Dalton, *Winslow Homer's Images of Blacks*, among other sources.
18. Sources on Winslow Homer include Craven; Flexner; Grossman; Holzer and Neely; Chowder, "Winslow Homer: Quintessential American Artist"; Simpson; Wilmerding, *Winslow Homer*; and Wood and Dalton, among others.
19. This section draws upon information presented in Kunhardt and Kunhardt, *Mathew Brady and His World*; Horan, *Mathew Brady*; Meredith, *The World of Mathew Brady*; Catton *et al.*, *The American Heritage Picture History of the Civil War*; Katz, *Witness to an Era: Alexander Gardner*; and Gardner, *Gardner's Photographic Sketchbook of the Civil War*; among other sources.
20. Mathew Brady letter to Samuel Morse, 1855, Library of Congress, quoted in Kunhardt and Kunhardt, pp. 44–45.
21. Garrett *et al.*, p. 277.
22. Lucie-Smith, *American Realism*, p. 14.
23. Johnson, *An Enduring Interest*, p. 59.
24. Sweet, *Traces of War*, p. 112.
25. This section is informed by Sweet's thoughtful analysis of Civil War photography.
26. See Sweet, especially chapters 3, 4, and 5.
27. Gardner and his assistant O'Sullivan were permitted aboard the ship *Montauk* to photograph the body of Lincoln's assassin, John Wilkes Booth, at the official post-mortem examination on May 13, 1865. Only one negative and print were allowed to be made, and these were turned over to the Secretary of War. Despite the testimony of witnesses, officials later denied that any photograph was ever taken (Johnson, *An Enduring Interest*, p. 77).
28. Thompson, p. 185.
29. Johnson and Buel, *Battles and Leaders*, 1888, discussed at length in Sears.
30. See Moat, *Frank Leslie's Illustrated History of the Civil War*. Many of the original drawings and paintings from *Battles and Leaders of the Civil War* were published in a beautiful volume by the American Heritage Publishing Co. (Sears). In the older publication, the works of art were rendered as engravings, while in the modern volume, the drawings and paintings were reproduced directly from the originals.
31. This section derives information from many sources, including Gardner; Horan; Horan, *Timothy O'Sullivan*; Johnson; Katz; Kunhardt; Lossing, *Mathew Brady's Illustrated History of the Civil War*; Meredith, *The American Wars*; and Newhall, *T. H. O'Sullivan*.
32. Johnson, pp 64–67; Katz, pp. 270, 276–77.
33. Information on cycloramas is from Holzer and Neely; Ellis, *Atlanta Cyclorama*; Columbia Panorama Co.; Union Square Panorama Co.; and Atkinson, *Descriptive Catalogue of the Cyclorama, "Storming of Missionary Ridge," and "Battle Above the Clouds."*
34. Information in this section derives from Widener, *Confederate Monuments*; Panhorst, *Lest We Forget*; and several other sources.

Bibliography

Angle, Paul M. *A Pictorial History of the Civil War Years*. Garden City, N.Y.: Doubleday & Co., 1980.
Atkinson, Paul M. *Descriptive Catalogue of the Cyclorama, "Storming of Missionary Ridge," and "Battle Above the Clouds."* Atlanta: J. A. McCown, 1891.
Billings, John D., and illustrated by Charles W. Reed. *Hardtack and Coffee, or The Unwritten Story of Army Life*. Boston: 1887. Reprinted in Glendale, N.Y., by Benchmark Publishing Corp., 1970.
Blay, John S. *The Civil War: A Pictorial Profile*. New York: Thomas Y. Crowell Co., 1958.
Buchanan, Lamont. *A Pictorial History of the Confederacy*. New York: Crown, 1951.
Carpenter, Francis B. *Six Months at the White House with Abraham Lincoln*. New York: Hurd and Houghton, 1866.
Catton, Bruce, Richard M. Ketchum, and the Editors of American Heritage. *The American Heritage Picture History of the Civil War*. New York: American Heritage (Distributed by Doubleday), 1982 [1960].
Chowder, Ken. "Winslow Homer, the Quintessential American Artist." *Smithsonian*, October 1995, pp. 116–129.
Columbia Panorama Co. *Descriptive Catalogue of the Cyclorama of the Battles of Vicksburg*. New York: n.d. [19th century].
Commager, Henry Steele, ed. *Illustrated History of the Civil War*. New York: Exeter Books (Simon & Schuster, Inc.), 1976.
Craven, Wayne. *American Art, History and Culture*. New York: Harry N. Abrams, and Brown & Benchmark, 1994.
Cromie, Alice Hamilton. *A Tour Guide to the Civil War; The Complete State-by-State Guide to Battlegrounds, Landmarks, Museums, Relics, and Sites* (fourth ed.). Nashville: Rutledge Hill Press, 1992.
Cullen, Jim. *The Civil War in Popular Culture: A Reusable Past*. Washington and London: Smithsonian Institution Press, 1995.
Davis, Theodore R. "How a Battlefield is Sketched," *St. Nicholas*, Vol. XVI, No. 9, July 1889, pp. 661–68.
Davis, William C., ed. *The Image of War* (6 vols.). Garden City, N.Y.: Doubleday & Co., 1983.
———. *Touched By Fire: A Photographic Portrait of the Civil War*. Boston: Little, Brown, 1985.
Dawson, William Forrest, ed. *A Civil War Artist at the Front; Edwin Forbes' Life Studies of the Great Army*. New York: Oxford University Press, 1957.
Donald, David, ed. *Divided We Fought: A Pictorial History of the War 1861–1865*. New York: Macmillan, 1952.
Ellis, Robert D. *Atlanta Cyclorama*. Civil War Series Video. Philadelphia: Eastern National Park and Monument Association, 1989.
Flexner, James Thomas, and the Editors of Time-Life Books. *The World of Winslow Homer, 1836–1910*. New York: Time, 1966.

Forbes, Edwin. *Thirty Years After: An Artist's Story of the Civil War*. New York: Fords, Howard, and Hulbert, 1890. (Reprinted in 1993 in Baton Rouge by the Louisiana State University Press.)
Gardner, Alexander. *Gardner's Photographic Sketch Book of the Civil War*. New York: Dover, 1959. Reprint of original 1866 edition, with a new introduction and index.
Garrett, Wendell D., Paul Norton, Alan Gowans, and Joseph T. Butler. *The Arts in America: The Nineteenth Century*. New York: Charles Scribner's Sons, 1969.
Grossman, Julian. *Echo of a Distant Drum: Winslow Homer and the Civil War*. New York: Harry N. Abrams, 1974.
Hill, Jim Dan. *The Civil War Sketchbook of Charles Ellery Stedman*. San Rafael, CA: Presidio Press, 1976.
Holmes, Oliver Wendell. "Doings of the Sunbeam," *Atlantic Monthly*, July 1863.
Holzer, Harold, and Mark E. Neely, Jr. *Mine Eyes Have Seen The Glory: The Civil War in Art*. New York: Orion Books, 1993.
Horan, James D. *Mathew Brady: Historian With a Camera*. New York: Bonanza Books, 1955.
———. *Timothy O'Sullivan: America's Forgotten Photographer*. Garden City, N.Y.: Doubleday & Co., 1966.
Johnson, Brooks. *An Enduring Interest: The Photographs of Alexander Gardner*. Norfolk, VA: The Chrysler Museum, 1991.
Johnson, Rossiter. *Campfire and Battlefield: The Classic Illustrated History of the Civil War*. New York: The Fairfax Press, 1978. (Reprint of 1894 edition, New York: B. Taylor.)
Johnson, R. U., and C. C. Buel, eds. *Battles and Leaders of the Civil War*. 4 vols. New York: The Century Co., 1888.
Jordan, Robert Paul. *The Civil War*. Washington, D.C.: National Geographic Society, 1969.
Katz, D. Mark. *Witness To An Era: The Life and Photographs of Alexander Gardner. The Civil War, Lincoln, and the West*. New York: Viking, 1991.
Kelbaugh, Ross J. *Introduction to Civil War Photography*. Gettysburg, PA: Thomas Publications, 1991.
Kirkland, Frazar. *The Pictorial Book of Anecdotes and Incidents of the War of the Rebellion*. Hartford, CT: Hartford Publishing Co., 1866.
Kunhardt, Dorothy Meserve, and Philip B. Kunhardt, Jr. *Mathew Brady and His World*. Alexandria, VA: Time-Life Books, 1977.
Kunhardt, Philip B., Jr., P. B. Kunhardt III, and P. W. Kunhardt. *Lincoln: An Illustrated Biography*. New York: Alfred A. Knopf, 1992.
Lesy, Michael. *Bearing Witness: A Photographic Chronicle of American Life 1860–1945*. New York: Pantheon, 1982.
Lossing, Benson J. *Mathew Brady's Illustrated History of the Civil War, 1861–65, and the Causes that led up to the Great Conflict*. Compiled from The Official Records of the War Department, 1912. Undated modern reprint, The Fairfax Press.
Lowenfels, Walter. *Walt Whitman's Civil War*. New York: Alfred A. Knopf, 1961.
Lucie-Smith, Edward. *American Realism*. New York: Harry N. Abrams, 1994.
McPherson, James, and the Editors of Time-Life Books. *The Time-Life History of the Civil War*. Time-Life Books, 1990. New York: Barnes & Noble Books.
Meredith, Roy. *The American Wars: A Pictorial History from Quebec to Korea, 1755–1953*. Cleveland and New York: World Publishing, 1955.
———. *The World of Mathew Brady: Portraits of the Civil War Period*. Los Angeles: Brooke House, 1976.
Miller, Francis Trevelyan, ed. *The Photographic History of the Civil War* (10 vols.). New York: The Review of Reviews Co., 1911.
Moat, Louis Shepheard, ed. *Frank Leslie's Illustrated History of the Civil War*. New York: Mrs. Frank Leslie, 1895.
Montgomery, Walter, ed. *American Art and American Art Collections*. Boston: 1889.
Moore, Frank. *Women of the War: Their Heroism and Self-Sacrifice*. Hartford, CT: S. S. Scranton & Co., 1866.
Mugridge, Donald H., compiler. *The Civil War in Pictures 1861–1961: A Chronological List of Selected Pictorial Works*. Washington, D.C.: Library of Congress, 1961.
Neely, Mark E., Jr., Harold Holzer, and Gabor S. Boritt. *The Confederate Image: Prints of the Lost Cause*. Chapel Hill: University of North Carolina, 1987.
Newhall, Beaumont and Nancy. *T. H. O'Sullivan, Photographer*. Rochester, NY: George Eastman House, 1966.
Panhorst, Michael Wilson. *Lest We Forget: Monuments and Memorial Sculpture in National Military Parks on Civil War Battlefields, 1861–1917*. Ph.D. Dissertation, 1988, University of Delaware; Microfiche, Ann Arbor, Michigan.
Pierce, Sally, and Temple D. Smith. *Citizens in Conflict: Prints & Photographs of the American Civil War. A Catalogue of an Exhibition held at the Boston Athenaeum*. Boston: Boston Athenaeum, 1981.
Pratt, Fletcher. *Civil War in Pictures*. New York: Henry Holt, 1955.
Rainey, Sue. *Creating "Picturesque America": Monument to the Natural and Cultural Landscape*. Nashville: Vanderbilt University Press, 1994.
Ray, Frederic E. *Alfred R. Waud: Civil War Artist*. New York: Viking, 1974.
Rosenburg, R. B. *Living Monuments: Confederate Soldiers' Homes in the New South*. Chapel Hill: University of North Carolina, 1993.
Russell, Andrew J. *Russell's Civil War Photographs*. New York: Dover, 1982.
Sala, George Augustus. *My Diary in America in the Midst of War*. London: Tinsley Bros., 1865.
Sears, Stephen W., ed. Foreword by Bruce Catton. *The American Heritage Century Collection of Civil War Art*. New York: American Heritage Publishing, 1974.
———. *The Civil War: A Treasury of Art and Literature*. New York: Hugh Lauter Levin Associates, 1992 [distributed by Macmillan].
Simon, Irving B. *The Story of Printing: From Wood Blocks to Electronics*. Irving-on-Hudson, NY: Harvey House, 1965.
Simpson, Marc. *Winslow Homer: Paintings of the Civil War*. San Francisco, CA: The Fine Arts Museums of San Francisco, Bedford Arts, 1988.
Stern, Philip Van Doren. *They Were There: The Civil War in Action as Seen by its Combat Artists*. New York: Crown Publishers, 1959.
———. *The Civil War Christmas Album*. New York: Hawthorn Books, 1961.
Sullivan, Constance, ed. *Landscapes of the Civil War: Newly Discovered Photographs from the Medford Historical Society*. New York: Alfred A. Knopf, 1995.
Sweet, Timothy. *Traces of War: Poetry, Photography, and the Crisis of the Union*. Baltimore and London: Johns Hopkins University Press, 1990.
Thompson, William Fletcher, Jr. *The Image of War: The Pictorial Reporting of the American Civil War*. New York: Thomas Yoseloff, 1960.
Time-Life Books, editors. *The Civil War* (28 vols.). Alexandria, VA: Time-Life Books, 1984.
Tinling, Marion. *Women Remembered: A Guide to Landmarks of Women's History in the United States*. New York: Greenwood Press, 1986.
Union Square Panorama Co. *The Greatest Work of the Celebrated French Artist, Paul Philippoteaux; The Cyclorama of the Battle of Gettysburg*. Souvenir, Union Square Panorama Company, Union Square, New York: n.d. [19th century].
Wakeman, Geoffrey. *Victorian Book Illustration: The Technical Revolution*. Newton Abbot: David & Charles, 1973.
Ward, Geoffrey C., with Ric Burns and Ken Burns. *The Civil War: An Illustrated History*. New York: Alfred A. Knopf, 1990.
Widener, Ralph, Jr. *Confederate Monuments: Enduring Symbols of the South and the War Between the States*. Washington, D.C.: Andromeda Associates, 1982.
Wiley, Bell Irvin. *Embattled Confederates: An Illustrated History of Southerners at War*. New York: Harper & Row, 1964.
Williams, Hermann Warner, Jr. *The Civil War: The Artists' Record*. Washington, D.C.: The Corcoran Gallery of Art, 1961.
Wilmerding, John. *Winslow Homer*. New York: Praeger, 1972.
Wood, Peter, and Karen C. C. Dalton. *Winslow Homer's Images of Blacks: The Civil War and Reconstruction Years*. Austin (Menel Collection): University of Texas Press, 1988.
The World Book Encyclopedia (22 vols.). Chicago: World Book, 1980, 1995.

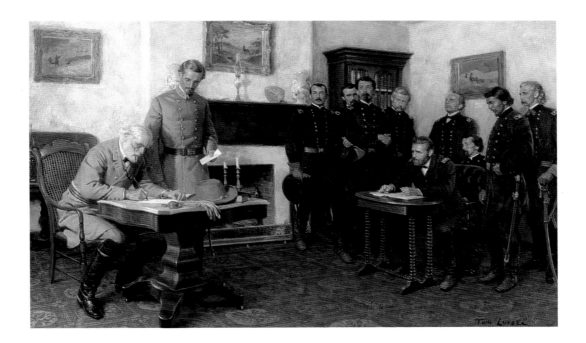

The Surrender at Appomattox, 1865

THOMAS LOVELL *1965; oil on canvas. The National Geographic Society.*

The end of the war came with the signing of agreements by General Lee, left, and General Grant, right, each attended by aides. No artist was at hand to record the actual event, and many renditions of the surrender suffer from factual inadequacies. The most accurate version is this painting, completed as part of the centennial celebration of the Civil War.

Index

Page numbers in **bold-face** type indicate photo captions.